Drawing
for Pleasure

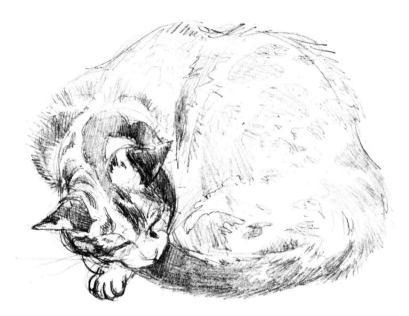

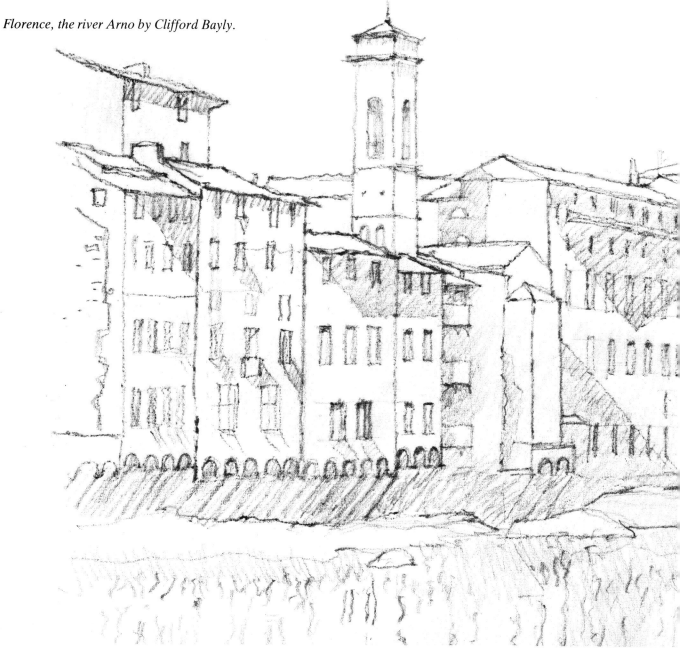

Florence, the river Arno by Clifford Bayly.

Drawing
for Pleasure

Norman Battershill · Clifford Bayly · John Blockley
Richard Bolton · Peter Caldwell · Ray Campbell Smith · George Cayford
Sylvia Frattini · James Lester · Margaret Merritt · Sally Michel
Rosanne Sanders · Leslie Worth · Jack Yates

Edited by Valerie C. Douet

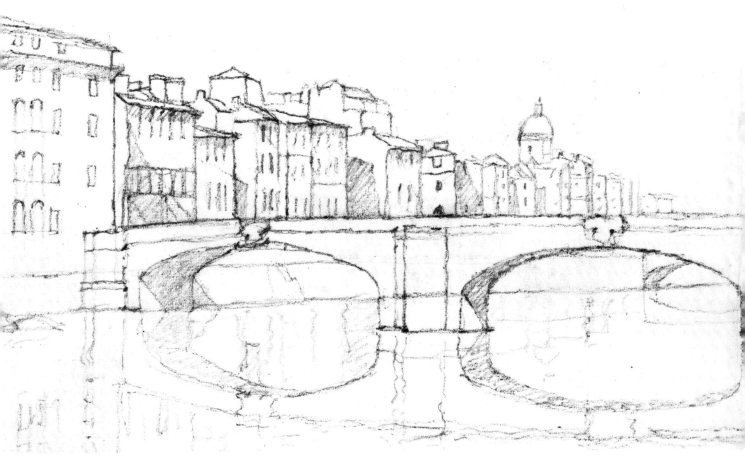

SEARCH PRESS

First published 1983
Search Press Ltd.,
Wellwood, North Farm Road,
Tunbridge Wells, Kent TN2 3DR

Reprinted 1984, 1986

New edition published 1992

Reprinted 1993

Original edition edited by Peter D. Johnson
New edition edited by Valerie C. Douet

Cover design by Clifford Bayly

ISBN 0 85532 705 7

Composition by Genesis Typesetting, Rochester, Kent
Printed in Spain by Elkar S.Coop

Contents

Introduction

In its simplest form, drawing is a language, from which other written languages and visual communication have developed. Almost from the cradle, children draw and some of their untutored images are inventive and original. As other interests crowd in, the creative urge may fade, but the instinct is still there, even though it may lie dormant. For some, drawing will continue to be a natural form of expression, while for others it has to be an acquired skill and the result of continual practise and study.

Drawing is not only the foundation for all painting. As you can see by looking at any artist's sketch-book, sketches are personal shorthand notes, recording their preoccupations with the world about them.

No matter what your level of competence, making marks on paper is also a pleasant and relaxing experience that will encourage you to look more closely at your surroundings and to understand them better.

The artists who have contributed to the making of this book are professionals and teachers who are happy to share their enthusiasm and the skills of their craft with others. There are no great secrets to drawing well, but a few technical hints from people who really know how will help.

As Peter Caldwell says in his book *Drawing Light and Shade*, 'With a little perseverance, the ability to draw is in all of us, even if the results are not as good as we would like. . . . Learning to draw is rather like learning to drive a car. There are three stages: first you need to be shown the basic equipment; then you have to go through the sometimes agonizing process of constant practise while getting accustomed to which piece of equipment does what; finally there is a gradual realization that you are drawing without thinking about the method, and consequently you are much more relaxed and the experience is more enjoyable.'

There are as many approaches to drawing as there are artists and as wide a variety of techniques and materials, many of which are covered in this book. One person may want to achieve a realistic rendering of objects in light and shade, for which perspective, structure, scale, lighting and tone are needed. Another may prefer a two-dimensional style, or wish to experiment with different physical qualities of paper, media and methods of producing exciting graphic effects. A drawing can be a few disciplined lines in pen and ink, or it can be some thick, flowing brush strokes. It can be enhanced to give a three-dimensional effect with wash and tone, or reduced to an abstract two-dimensional pattern. Whatever area of drawing you explore, the result will be a form of personal expression with its own unique quality, which will reflect the enjoyment and the personality of the artist.

As well as being fun, sketching trains the eye wonderfully, so with any spare time you have, take a pencil or felt-tipped pen and a small sketch-book and go out and make notes of people, plants, animals, buildings, landscapes or whatever it is that you wish to capture on paper. Mechanical accuracy is not the object of the exercise; if that is what you want to achieve, then use a camera (in fact, many artists do carry a camera, for photographs can be useful for reference purposes). What is most important is your response to whichever aspect of your subject first appealed to you, whatever it was that made you want to draw it on paper, so it is well worth taking the trouble to work directly from the world about you. If this results in a little exaggeration here and there, then so be it, for we cannot convey our emotional reaction to the image that first excited us without emphasizing some part of it.

Be a little selfish and put your drawing first, if that is what you want to do. There will always be other demands on your time and if you are to succeed, then you must be determined. Above all, practise, practise, practise!

Pages from the artists' sketch-books.

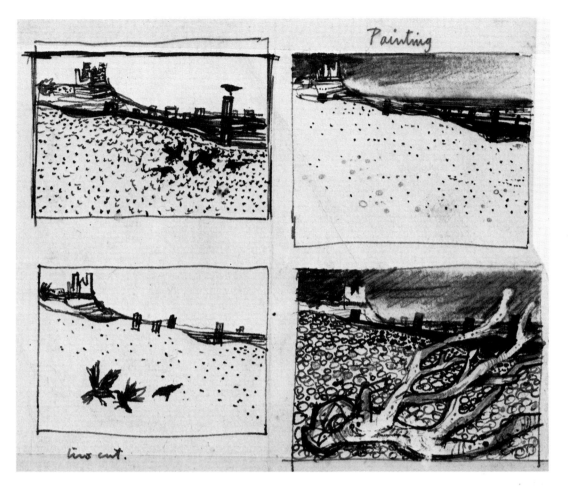

'*I always take sketching materials with me when I travel. A flat sketch pad takes up little room. Sometimes I take a camera as well, but I prefer to be selective, so I augment my camera studies with line and tone sketches of detail.*'

Clifford Bayly

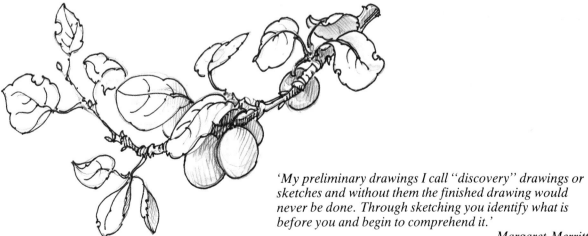

'*My preliminary drawings I call "discovery" drawings or sketches and without them the finished drawing would never be done. Through sketching you identify what is before you and begin to comprehend it.*'

Margaret Merritt

Introduction

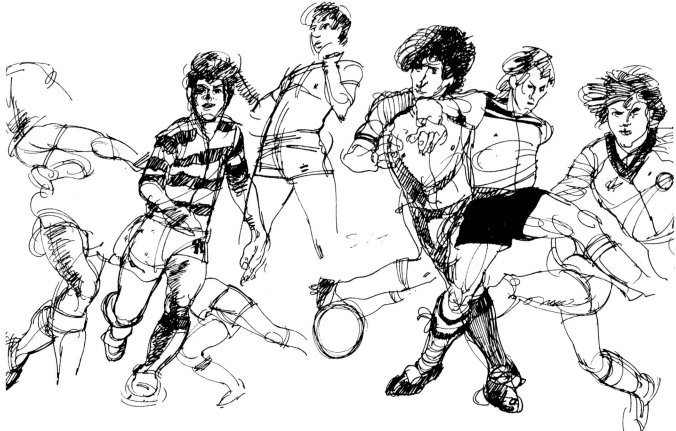

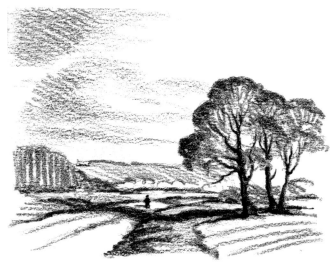

'I drew these footballers in action while I was watching TV. I hardly lifted my pen from the paper and I probably only glanced at what I was doing a few times. You have to hold your eye on the subject and not keep looking at what you are drawing.'

George Cayford

'I made these sketches of the countryside near my home one fine autumn day. I used a 4B pencil on "Not" watercolour paper in pad form and concentrated on capturing the essence of the scene and eliminating all unnecessary detail.'

Ray Campbell Smith

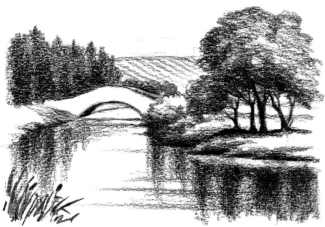

'I use my sketch-book to record anything interesting or unusual; I never tire of sketching and I enjoy the challenge of putting pen and pencil to paper.'

Peter Caldwell

'Whenever possible I try to do some sketching. It is useful to build up reference material for later use and it makes you study the subject closely from different angles, thus deepening your understanding.'

Rosanne Sanders

'When making studies of animals it is often necessary to concentrate on the overall posture and proportions of the animals rather than the detailed structure of noses, ears and eyes, which can be shown in separate small drawings.'

Sally Michel

9

Equipment and materials

Unless you are making quick on-the-spot drawings, when the object is to record the subject as quickly as possible, it is best to make yourself comfortable.

A flat table is the most convenient working surface but a tilted drawing-board will allow your pen or pencil to move over the surface without you having to stretch. Sit so that there will be no shadows cast by your drawing hand on the point of contact of pen or pencil. This will enable you to see the strength of line or tone clearly as you work.

If you like to draw standing up, then you will need an easel and a firm drawing-board on which to pin the paper. This gives the arm greater freedom to move naturally and in turn creates a free style of drawing. On the other hand, sitting is conducive to greater control over the hand, as the wrist can be rested on the board or pad.

An angler's stool is ideal for working out-of-doors, as it is light-weight and it folds. Keep materials readily accessible by your side, if possible in a waterproof holder. Fix the paper to the board with pins, tape or clips and add a sun-hat and a light raincoat to your outdoor equipment.

You can draw with anything from a stick of charred wood to a computer, but your marks will be meaningless unless they produce a description of what you have seen and perceived. Your choice of media should be dictated by the type of drawing you intend to make and its purpose. Because of the huge range of materials on the market, it is essential to appreciate their inherent qualities and characteristics.

Pencils

These range from very hard (6H) to very soft (7B). F and HB pencils come midway in the scale. For fine drawing, a good point is needed, and the pencil should be selected from the middle to hard range. Architectural and machine drawing usually require a very hard pencil. Tone drawing requires a softer pencil from the B range. There are also special pencils, such as carbon and Conté pencils in several grades, which are useful for making good solid marks, but which smudge readily. Conté crayons are a special form of hard pastel available in black, brown, sanguine, and white, in the form of a facetted stick. If you use these, then you will also need a fixative. Clutch pencils, which grip a separate lead element, are useful when it is impractical to sharpen a wood pencil.

Crayon

This covers a variety of composite materials, either in sticks with paper wrappers (such as wax crayons) or in special compositions of pigment and binding agents contained within a pencil format. Watercolour pencils and crayons fall into this category. They are water-soluble and the black is a particularly useful drawing tool, for the marks it makes can be softened by the application of a wet brush or even with a moistened finger, to give an interesting attractive line and wash effect.

Wax Crayons

These are quite soft and do not smudge easily. They are useful for large, bold sketches. Oil pastels, chinagraph and lithographic chalks have a similar quality and feel to wax crayons and can be used on almost any type of paper.

Pastels

Pastels are made by compressing powdered pigment with chalk to control their softness or hardness. A pastel pencil is generally harder than a pastel stick; it can be sharpened to a point and is therefore used for detailed drawing. The pastel stick is used for drawing broad areas or for blending with the fingers.

The artist Dennis Frost gives a good tip for cleaning grubby pastels. 'Keep a separate tray or large deep tin filled with about 5cm (2in) of cooking rice. At the end of the day, drop the used pastels into this and agitate for a few minutes until they are clean and ready for reuse.'

Brushes

It is quite possible to draw with a brush, and to produce fluid, beautiful lines. Drawings can be supplemented effectively with the brush by adding washes and texture, or by using the brush to produce heavier lines, or to soften the drawing by dissolving away parts of the existing work.

Pens

The most basic form of pen is a sharp stick dipped in ink, which gives a reasonably good line of informal quality, that is, blobby. Pens can be cut from large feathers and used as quills, or a reed can be cut and used as in the traditional reed pen. In both cases, cut the end at a steep angle and slit the point. Ordinary steel-nibbed pens, obtainable from stationers or art shops, are most commonly used (wash them in soap before using them).

Marks made by Clifford Bayly using various media.

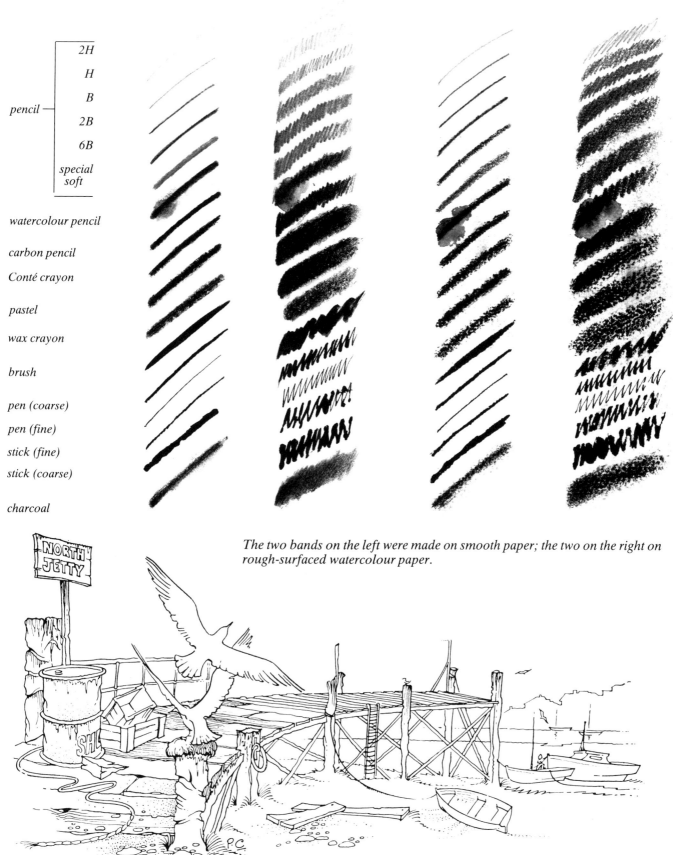

pencil — 2H
H
B
2B
6B
special
soft

watercolour pencil

carbon pencil

Conté crayon

pastel

wax crayon

brush

pen (coarse)

pen (fine)

stick (fine)

stick (coarse)

charcoal

The two bands on the left were made on smooth paper; the two on the right on rough-surfaced watercolour paper.

Jetty in pen and ink by Peter Caldwell.

Equipment and materials

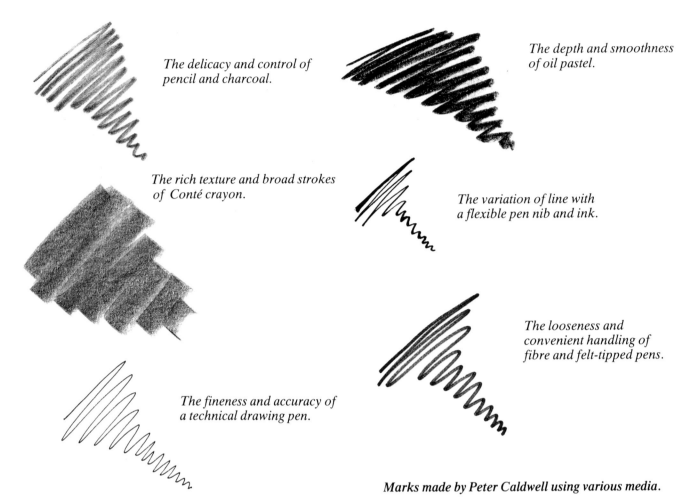

The delicacy and control of pencil and charcoal.

The depth and smoothness of oil pastel.

The rich texture and broad strokes of Conté crayon.

The variation of line with a flexible pen nib and ink.

The fineness and accuracy of a technical drawing pen.

The looseness and convenient handling of fibre and felt-tipped pens.

Marks made by Peter Caldwell using various media.

Unless you specialize in very fine, controlled work, avoid pens which make a mechanical line of uniform thickness, such as ball-point and some fountain pens. Another disadvantage of ball-point is that it will not withstand exposure to light; no ball-point pen drawing should be framed or sold, although, of course, a light-fast reproduction of it could be made.

Fibre-tipped pens are occasionally permanent and are bold and fast. There are waterproof and non-waterproof varieties, the latter useful for quick tonal effects, since they give a blurred line when used with water. Fibre-tipped pens give a line which is even in width and tone, although you can vary this by using thick and thin nibs.

On the whole, a soft, flexible nib which can produce both fine and heavy lines, according to the pressure exerted, is the most expressive drawing tool.

Charcoal

Charcoal is made of twigs or thin sticks baked at a high temperature until they are evenly charred throughout. They give an even, very black line, seen to best advantage on a coarse-surfaced paper. Charcoal smudges easily, so it needs to be fixed for permanence. It can spread to parts of a drawing which were intended to remain light, yet this is an essential characteristic of the medium and should be utilized where possible.

Inks

These can be either waterproof or water-soluble. Waterproof inks are usually used for line and wash work, so that the drawing is not disturbed by the addition of subsequent washes. Black ink is most commonly used, and some artists find black fountain pen ink, or black or sepia manuscript ink, very useful as these do not clog the nib.

Chinese stick ink gives beautiful greys and a soft black; dissolve the solid ink stick by rubbing it into a saucer.

When you wish to dilute inks, use distilled water or rain-water. Tap water can cause many inks to curdle and many watercolour inks to fade rapidly.

Erasers

These are needed from time to time, to erase charcoal or pencil completely or to produce highlights. The best type of eraser is one made of putty, although you can also use white bread moulded into a lump to soften a line and reduce its tone. Modern plastic erasers are probably the best all round material to use, however, as they stay cleaner.

Papers

Bleached rag provides the best modern quality papers; esparto (grass) and wood-pulp are used for the less expensive to the cheapest paper.

Papers can be hard, soft, rough or smooth, white or coloured; from the thickness of stiff board to the flimsiest of tissues. Cartridge paper is the most popular paper for drawing and this is available in smooth, semi-smooth and rough surfaces. For detailed work, choose a smooth paper which easily takes a fine line. Always buy the best quality paper you can afford, as it is much more pleasant to work on.

Ingres paper has a soft, furry surface ideal for pastel drawings and is made in a variety of light colours.

Bristol board is a smooth, hard white board used for fine pen work. It can be bought in various thicknesses.

Sugar paper and Carson both have textures which can give a pleasant and enriching effect to a drawing.

You can buy sketch-books containing nearly all of these papers. Ray Campbell Smith finds a 'Not' (cold pressed) paper the most sympathetic, for the slight roughness of its surface produces a rather grainy line. A smooth (hot pressed) paper usually gives a harder, more uncompromising line. Try drawing on sketching paper or on a layout pad – even a lined exercise book is better

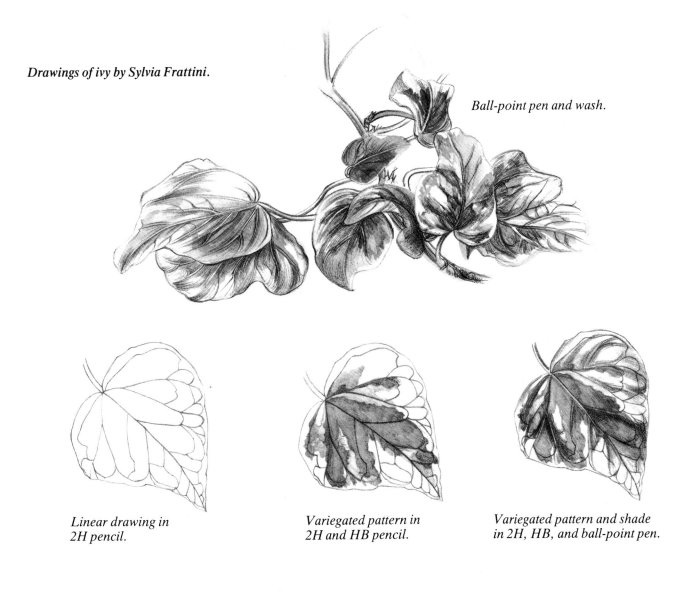

Drawings of ivy by Sylvia Frattini.

Ball-point pen and wash.

Linear drawing in 2H pencil.

Variegated pattern in 2H and HB pencil.

Variegated pattern and shade in 2H, HB, and ball-point pen.

Equipment and materials

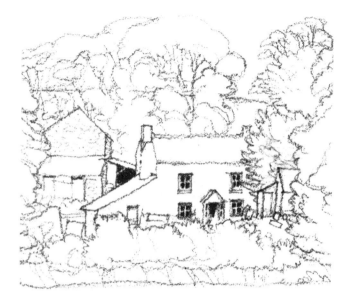

Cottage drawn on rough watercolour paper with a 6B pencil.

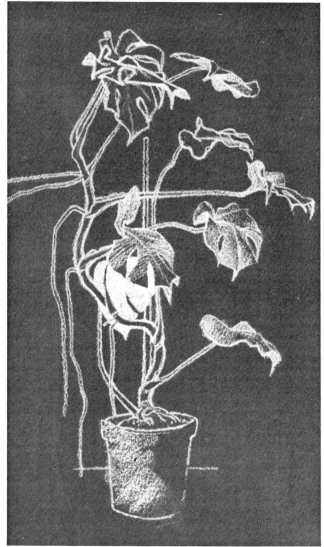

Pot plant in white Conté on light brown Ingres paper.

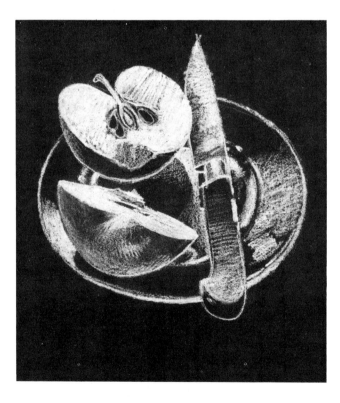

Apples on a plate in white Conté on black sugar paper.

Drawings by Clifford Bayly.

than no paper at all. Always have drawing paper available at home or in your pocket when you are out of the house. Clifford Bayly carries two sketch pads, a small one that fits into his jacket pocket and a larger one for the car. Both are ring bound and of thickish paper because thin paper cockles when he wets it to use his watercolour pencil. Two grades of paper are sufficient for his needs; a fairly smooth cartridge and a rougher watercolour paper.

If Syliva Frattini is to spend some time working on a picture, then she stretches her paper to provide a permanently flat surface on which to work. She immerses the paper in water for a few minutes, then lays it on a clean board. She fixes the paper to the board with brown gummed paper strip and allows any surplus water to run off freely before leaving the board flat to dry out. Any wrinkles in the paper will dry out as it contracts.

The drawings on this page demonstrate the use of various papers.

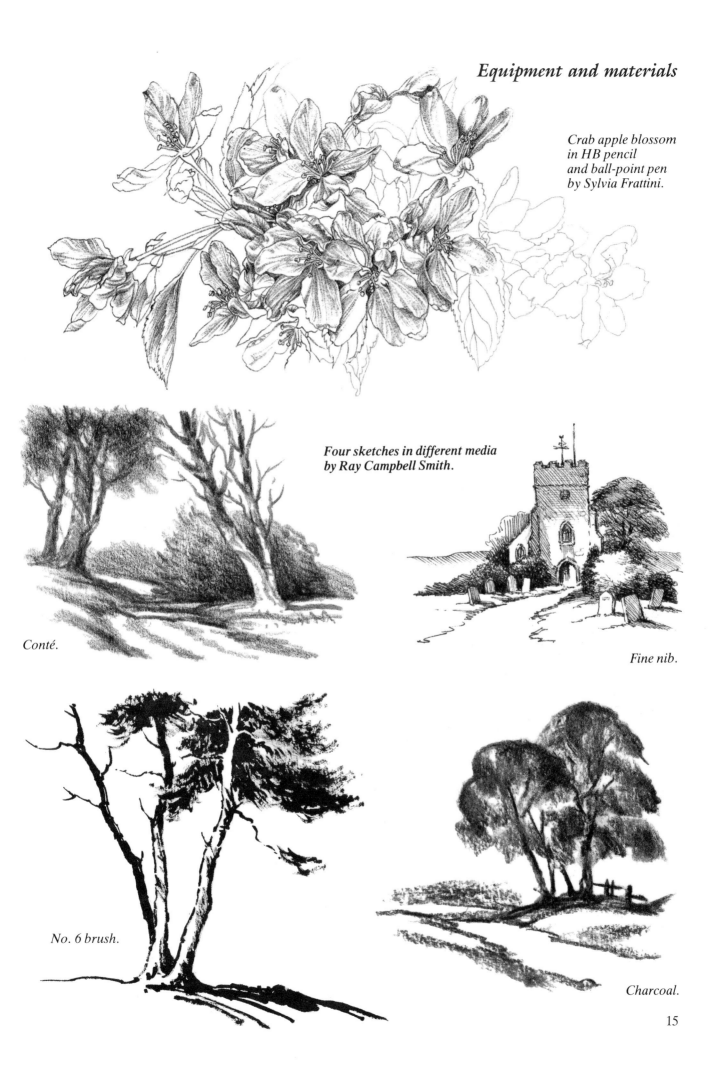

Equipment and materials

*Crab apple blossom
in HB pencil
and ball-point pen
by Sylvia Frattini.*

**Four sketches in different media
by Ray Campbell Smith.**

Conté.

Fine nib.

No. 6 brush.

Charcoal.

15

Equipment and materials

Using more than one medium

George Cayford suggests that once you have experimented with your range of media, you should try making marks with one over another. He says, 'Remember the general rule that "water wet" media will not "take" over greasy media such as wax crayon or oil pastel, but greasy ones will take over "dry" – which includes inks and watercolours once they are dry.'

What you will notice from these experiments is that you have at your disposal an array of new textures. 'Textural changes in a drawing', George Cayford continues, 'give a picture an added descriptive dimension. These can, of course, be achieved in only one medium: you have only to think of the wonderful drawings of the Old Masters to realize how they were able, in one medium, to depict fur, grass, flesh, cloth, stone and water. But an additional medium in one drawing is quite commonplace among the Great Masters. Pen and wash, charcoal and wash, Conté and pastel, three colours on tinted paper. They were doing what you and I will now be doing – suiting the media to the way you want to portray your subject.

'Here, I have drawn a cat in fine black felt-tipped pen, the background in charcoal. This may at first seem like a contradiction: the cat's fur after all is soft and the floor is hard – why shouldn't I choose a hard mark for a soft subject and a soft mark for a hard subject? The answer lies in the shape of the mark and lines I use. Nowhere have I drawn round the cat with a hard, unyielding line: instead, with short lines of even dots, I indicate fur

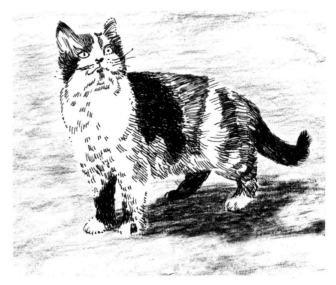

*Felt-tipped pen and charcoal drawing
by George Cayford.*

following the contours. Where the cat is black I hatch in strongly, where the fur is white just a few directional touches are all that is needed. If I had drawn the floor and background in with a "hard" medium, the cat's fluffiness, as I have depicted it, would have been lost. Imagine what my drawing would have looked like if I had used charcoal for the cat and felt-tipped pen for the background. The harsh black line of the felt-tipped pen would have swamped the soft charcoal drawing of the cat. Remember, it is the kind of mark you make that is the most expressive element in any drawing.'

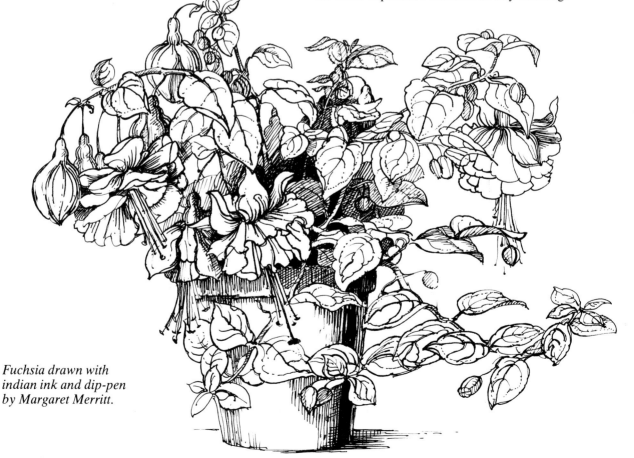

*Fuchsia drawn with
indian ink and dip-pen
by Margaret Merritt.*

*Drawings by Margaret Merritt to illustrate
the use of hard and soft media.*

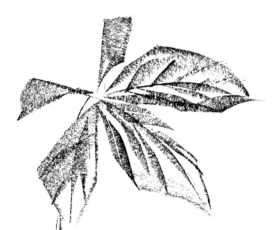

*Soft Conté in the BB range. To catch the
overall shape without detail, a small piece
of the stick was used on its side and the
pressure varied to give light and dark
effects. For final dark lines, to emphasize
structure, one of the points on the end was
used.*

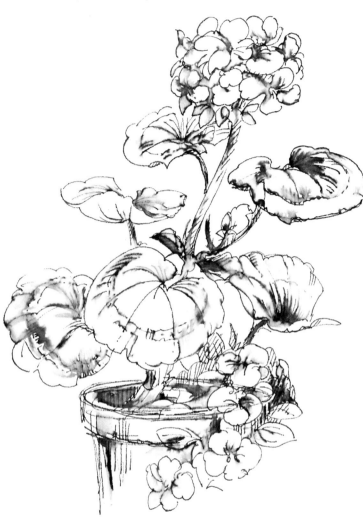

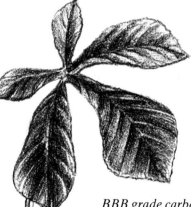

*Water-soluble marker. In this drawing, the
tones were loosened using a brush and
water.*

*BBB grade carbon pencil.
A more elaborate drawing
showing greater detail and form.
Used on its side,
the softness of the pencil
makes it appropriate
for shading.*

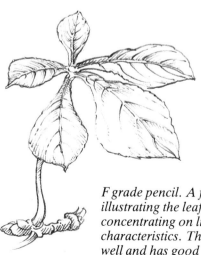

*F grade pencil. A fairly careful drawing
illustrating the leaf with the use of tone but
concentrating on line alone to show
characteristics. The pencil holds the point
well and has good dark and light tonal
range.*

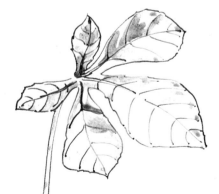

*Dip-pen and waterproof indian ink. A line
and wash drawing using watered-down ink
as the wash.*

Before you begin

Before you begin, here is some advice from the artists. 'Two of the most common ways of holding your drawing instruments are shown in the pictures on the right. The one that comes easily to most people is how they grip a pen when signing their names. The other depends less on finger or wrist movement than on moving your whole arm – you will find most professional artists employ it – as it allows you to make marks in any direction with more ease and eventual control. Keep your wrist and forearm free of the drawing surface whenever possible: try and realize your work "from the shoulder".

'One of the first habits you should cultivate when taking up drawing seriously is to carry around with you some sort of drawing material. Like the professional photographer who always carries a camera, so you must have in your handbag or coat pocket something to record what might catch your eye. Always have with you a small ring bound sketch pad and a couple of pencils. Felt-tipped pens are good for making lightning sketches – remember that, what you are after, most of the time, is not a finished drawing but a record. In the glove compartment of my car I always have my basic equipment – and my jacket pocket usually contains paper and pencils. For serious sketching, more elaborate equipment may be useful, but only to the point of being portable. Many beginners carry around too much equipment, which encumbers them to the extent that they are never comfortable or easy. Think of yourself as being part of your equipment – if you cannot move from viewpoint to viewpoint with ease, or climb up rocks or squeeze yourself into a corner of a street, then there will be little use for your equipment, for what you see is the important thing; and the more mobile you are, the more you will see.

'One problem that many beginners encounter, when faced with the panoramas that outdoor sketching provides, is that of selection of viewpoint and boundaries. As I have said, do not start sketching at once, but walk about, observe shapes and blocks, tones and lines. Some people find a simple viewfinder handy – most of you will be used to a camera viewfinder – so make one out of a stiff piece of card similar to the diagram on this page. This will both enable you to select that part of the panorama that you wish to depict, and tell you whether the composition is right. Then make sure you are as comfortable as possible, and set to work! Remember, it is not so much the work itself as the more intense observation engendered by your activity that is of immediate and lasting value.

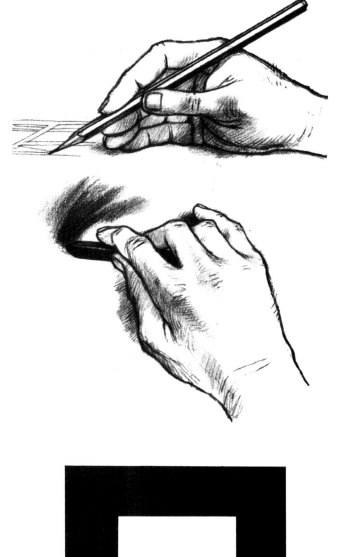

'Another problem which beginners face is what to put in, and what to leave out. Townscapes often present a plethora of jumbled detail, confusion and repetition. Sort out in your mind's eye what contributes to your picture and what is superfluous, and concentrate on the former. The main thing is to depict the principal forms and shapes accurately – detail can be added later.

'When putting in detail you will find that many parts are repeated: windows, doors, mouldings, for example. It is only necessary to draw one or even a part, the others being indicated by outline. This saves time when working outdoors; the unfinished parts can be put in at home, but it is necessary to complete the work as soon as possible while the images remain strong and fresh in the memory.

'Also, vary your use of media appropriately. A foreground object can be rendered simply and strongly with wax crayon or felt-tipped pen and more distant parts and fine detail with a sharp pencil or fine pen. Diluted ink washes can block in shadow areas quite quickly.'

Clifford Bayly

'It is always wise to spend time studying a subject before starting to draw, and to keep referring to it while transferring your impression on to the paper. As your eye follows the gentle slope of a hillside, the graceful shape of a vase, or the dramatic contours of rocks and falling water, your hand will soon learn to transfer the same shape to the paper almost without you being conscious of the pencil in your hand.

'Even when you are working on what you intend to be a highly finished picture, the preliminary sketching-in should be done in this manner, with quick, free lines which pay attention only to essential curves and shading.'

Peter Caldwell

'Before attempting a final drawing, I spend a long time sketching, photographing, planning and examining the plants I intend to use. When studying them, I try to understand how they grow – each one has its own special characteristics. Having photographed each plant several times, in case they die before I am able to draw them, I use no less than fifty photographs in the planning of a detailed picture. I cut out the larger shapes separately in paper and arrange them in a variety of ways to achieve the best results before planning the whole design on tracing-paper. Here, proportion and correct placing are important aspects of my work.

'Drawing underlies all techniques. Always sketch, when possible, from an actual model, whether it is a single plant or a general composition. Analyse the structure or form, be it the skeletal structure of flowers and leaves or broad masses of terrain or rock formations.

'Try to develop a bold, rhythmic use of line, working from the wrist and capturing nature's grace, which reveals itself in all organic growth. And never throw away an honest sketch; the time will come when you will find a good use for it!'

Sylvia Frattini

'Anyone who has ever walked down a country lane in spring or summer cannot fail to have been thrilled by the profusion of plants and flowers that grow, climb, twist and intertwine. To capture such experiences, of course, requires a certain competence and the best way to achieve them is by constantly making drawings, notes and sketches.

'Make it a habit always to carry a pencil and sketch pad – one small enough to slip into your pocket is quite sufficient – and to do quick studies wherever and whenever the opportunity arises. You will be surprised at how quickly your drawing will improve and your confidence increase.'

James Lester

'When I begin to study a subject, for example a tree, I become so involved with explaining the nature of the tree through drawing it that technique takes second place. It is only in later, more considered studies that technique takes precedence over the subject – and then I give more thought to the way I draw.

'Many people use photographs to work from and these are useful for a rainy day or for reference purposes but, in the early stages of learning, it is important to work directly from nature, because this adds vitality to a drawing.'

Margaret Merritt

'I did this drawing of flowers in an amusing vase with a fine needle-point pen, broad-nibbed pen and black ink, and washes of diluted ink applied with a brush. When I draw with the fine needle-point it seems as though I never lift my pen from the paper – which underlines how you should spend more time looking at the subject than at the drawing. If you practise enough, then you will find your hand will obey your eye without constantly having to watch what you are doing.'

George Cayford

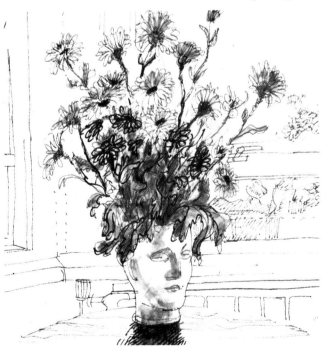

Making marks

Drawing has come a long way since man's earliest attempts at visual communication. Making marks in wet clay or sand; scratching marks on stone; indicating, perhaps with a burnt stick, on a flat surface – were some of the ways primitive man amplified his communication system with his fellows.

Here, Clifford Bayly has used his fingerprints as the starting point for two amusing bird pictures. As he says, 'Drawing is still a most important and basic means of communication when describing objects, systems, processes and expressing personal ideas. Nowadays, making marks on flat surfaces, whether in black and white, or in colour, has reached a high level of sophistication. Whether through such processes you wish to inform others about your ideas, or to convey your feelings about what you have seen: these two can be designated objective and expressive but in many cases each interacts and overlaps to a greater or lesser extent. The term drawing embraces now a very wide number of practical activities, which reflect the artist's ability to observe the subject objectively and perceive it subjectively. The result can be meaningless unless it is the result of intensive and careful observation by its creator, whatever the emotional response the subject projects to the onlooker.'

Drawing must be contained within the poles of objectiveness and expressiveness, according to whom you wish to communicate your ideas. Understand the process of communication by marks and you will have grasped the fundamentals of what drawing is about.

Having already discussed materials, now look more

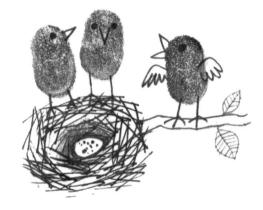

Marks and fingerprints by Clifford Bayly.

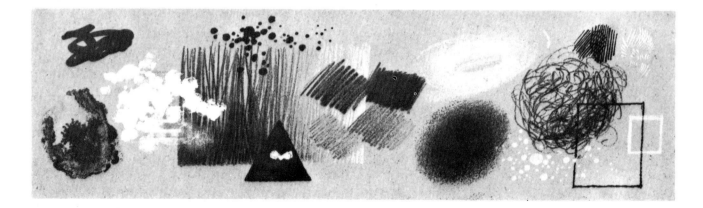

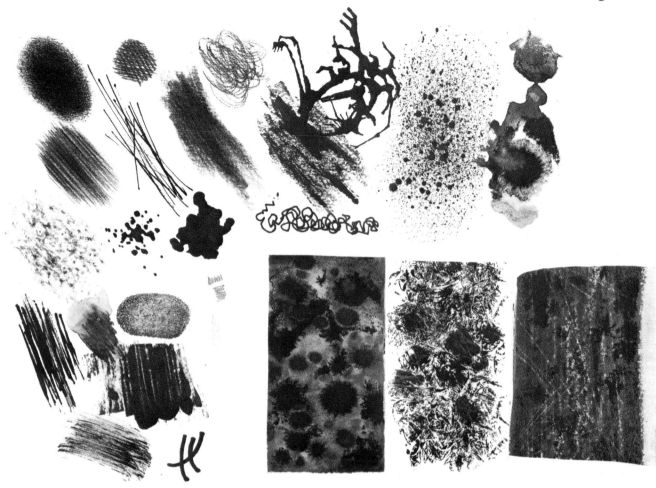

Blots, dabbings and scratchings: black ink blots on dampened paper; rag dabbings in black ink; Chinese ink wash and wax crayon scraped with a knife-point when dry. All by Clifford Bayly.

closely at the marks they make and into the possibilities these offer to record visual experiences and express your reactions to the subject. You need to develop a broad knowledge of how to produce these marks and be aware of their individual qualities so that you can use them skilfully – in short, to be technically as well as visually in control of your work.

A line is a mark – so too are fingerprints, a smear, spots and droplets, blots, scratches, etc. – all these can play a valuable part in drawing. In fact, any mark is useful but only when it is appropriate to what is being expressed in the drawing. Bayly says, 'Illustrated here are many such marks. In isolation they are meaningless, so I have shown some examples which occur naturally in drawings.

'Do not become preoccupied', he goes on, 'with the quality of marks for their own sake. It is possible to produce decorative effects that are attractive (as in some forms of illustration) but of little use if they do not carry useful information or express the subject satisfactorily. The way marks are applied to the paper tends to reflect the attitude of the artist. Broad, strong, direct strokes reflect confidence and an interest in the basic qualities

and mood of the subject: fine, precise line-work might show an intensity of interest in structure and detail.

'Just as the artist's subjective attitude to his subject is reflected in the quality of the marks made, so you have to make a conscious objective effort to use appropriate marks related to the subject-matter you are portraying. If you rely entirely on marks, then you are likely to neglect the concepts of form and structure. These must be present simultaneously in your drawings, otherwise they will appear flat and formless. Decorative and illustrative work can exist in a two-dimensional form, but if you are hoping to represent three-dimensional forms and distance, then some structural drawing is essential.'

George Cayford advises, 'First, search your home for all the pencils, pens, ball-points, chalks, crayons and markers that you, your husband or wife, or children may already have. After getting permission to use the ones you have borrowed(!) try them out on all kinds of surfaces – writing-paper, wrapping-paper, cardboard – to familiarize yourself with the sort of mark they make; do not draw anything, just scribble or run them on the surface and see what happens. In this way you will

Making marks

"feel" how they should best be used – after all, the medium is an extension of your arm and hand, and pressure or touch determines the mark.

'Now rub your finger over the mark. Does it smear or remain as it is? Wet your finger, do the same and observe the result. Take a brush and, with water, wet the surface thoroughly (some markers and pencil marks run, others are waterproof). When you have found out the characteristic mark or line of each medium, try applying one over another. Does the new mark "take"? Some pencils and crayons, however chalky they may appear, have a greasy binder and certain inks, markers and pencils will not go over them. Papers and surfaces too, have resistant or absorbent qualities. Make these experiments, therefore, for it is better to know the range and limitation of each medium and contemplate using them before you embark on actual picture-making. Then and only then, sally forth to the shops, knowing what you wish to purchase; shopkeepers and good assistants will be only too helpful if you need their advice on the range they have to offer.'

Opposite is an exciting landscape by Clifford Bayly, showing how different ways of making marks can add vitality and interest to a drawing. The foreground boulders were made with fingerprints and black ink blots, the grasses and flowers with a lightly dabbed rag soaked in ink, ink blots, and fine pen strokes. The middle distance was achieved by placing the paper on a rough stone surface and rubbing over it with a wax crayon. The trees were made with fingerprints and black wax crayon, while the hills beyond were created with small ink splashes and brush strokes of thinned ink.

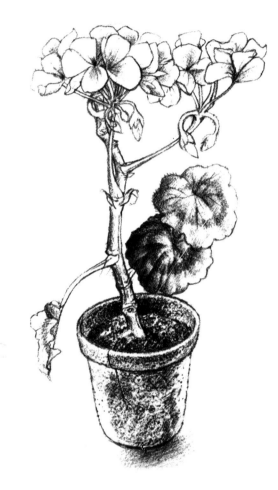

Geranium in a pot. This drawing by Clifford Bayly shows how effectively the use of different media can provide contrasts in texture. The plant was drawn in soft pencil, as was the outline of the pot, whose rough-grained texture was drawn in later with black crayon.

George Cayford approached his loosely described drawing of mixed seed heads by applying loose washes of Chinese ink with a brush and then going over the whole with a fine dip-pen in black ink.

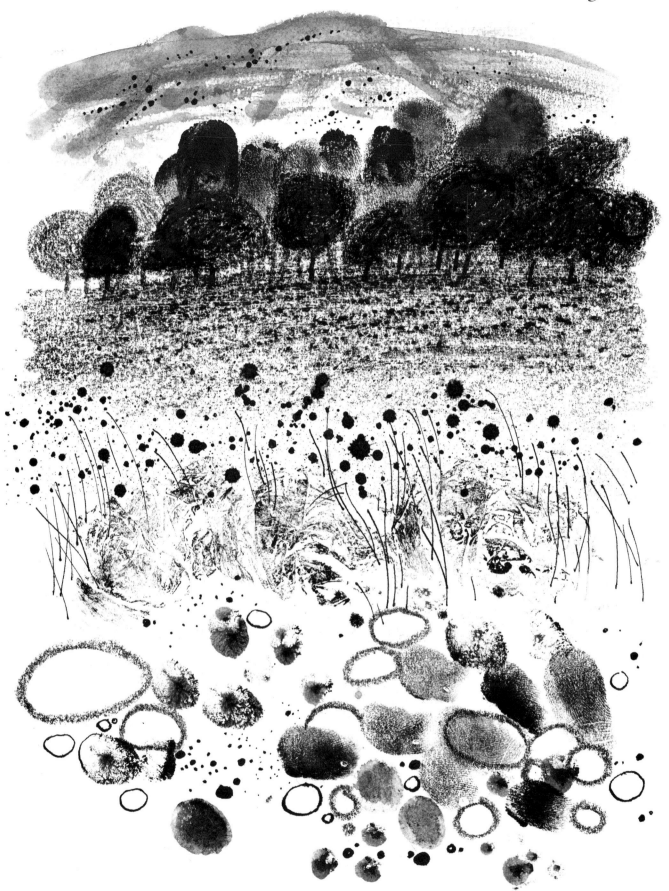

Drawing textures

It is always useful to know how to convey the texture of your subject in a drawing – the roughness of tree bark, the crumbling surface of a wall, of fur, feather and fin.

Practise the art of just suggesting a texture; for example, a few slates on a roof or a small scattering of stones on a beach. To put the problem simply, where there is an abundance of detail, as in foliage, sky, slates, brickwork, fur and so on, you can suggest texture by using some of the line techniques shown opposite. The mind's eye is adaptable enough to fill in any extra detail.

There are ways of suggesting texture other than by line alone. Clifford Bayly illustrates some imaginative ways of conveying the textures of buildings. He writes, 'As in icing a cake, texture should not be laid on so thickly as to obliterate the main structure. While I enjoy depicting the various materials of which a building is constructed, I am careful to indicate rather than portray. In a drawing of a small detail such as a gatepost to a house, it is appropriate to draw in all the bricks, but I would not do so when drawing a street of houses. A combination of tone and detail is probably the best balance to aim for'.

Drawings by Clifford Bayly.

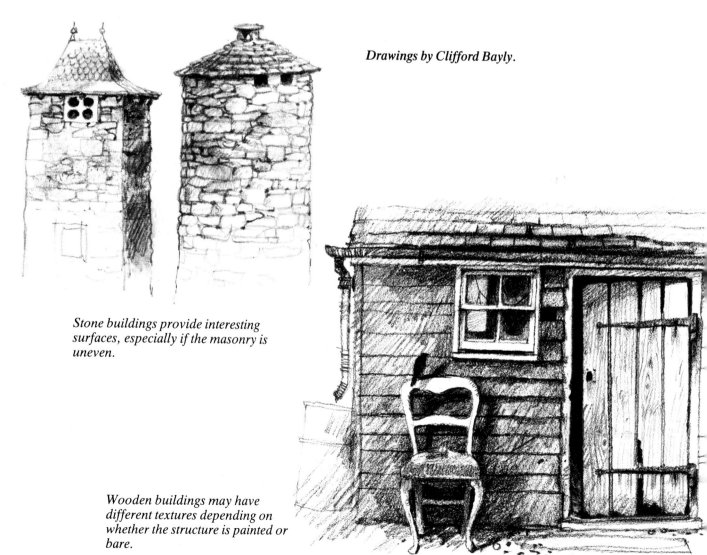

Stone buildings provide interesting surfaces, especially if the masonry is uneven.

Wooden buildings may have different textures depending on whether the structure is painted or bare.

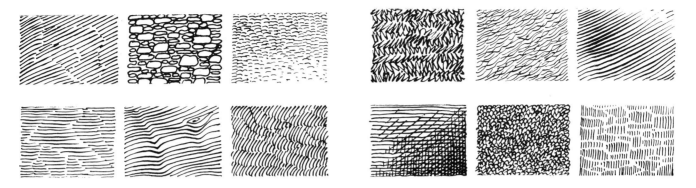

Line techniques by Peter Caldwell.

Carbon pencil gives rich blacks and a marked granulated effect when used on rough paper.

Lead pencil provides a wide range of tones, but is softer.

Watercolour pencil can be wetted with a brush and rubbed to give continuous tone.

Indent heavy watercolour paper with a dry point, then rub wax crayon over. The indentations simulate the mortar between bricks.

Drawn wax crayon with different pressures gives the effect of stone-built construction.

Drawing with pen and ink outlines the separation between crumbling textures; wax crayon over gives the contrast in textures.

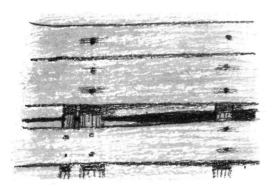

Brush diluted indian ink over rough watercolour paper with a stiff brush to give a streaky texture, then draw over with a dry medium (wax crayon or carbon pencil) to render ageing woodwork.

Draw over a diluted ink wash with pen and ink or black pencil medium to render brickwork, broken stucco, pebbledash.

Building textures by Clifford Bayly.

Drawing textures

Here, Sally Michel shows how to suggest a variety of animal textures, while on the page opposite, Margaret Merritt uses the simplest of media to convey a wealth of information about the forms and textures of trees.

Cat's eye in watercolour, pen, crayon and pastel. The thick, transparent cornea was done with a very wet wash of black watercolour; when it was half dry, clean water was dripped from a large brush and wiped dry to lift off the pigment from the middle of the eye, leaving a dark tone round the outside. When this was dry, fur, eyelids and pupil were defined with a fine pen. The tone in the eye was enhanced with crayon, which was also used to soften the edge of the fur and give depth. White pastel was used to provide extra brilliance.

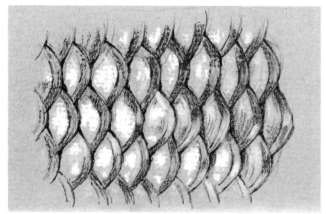

Fish scales drawn with a fine fibre-tipped pen, with white, grey, and black pastel pencils used over the top.

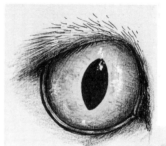

A 2H pencil and white pastel were used to convey the thin, tinny texture of the fish's eye.

The soft fur of the cat's foot is suggested by thin strokes of a well-sharpened crayon over a watercolour wash.

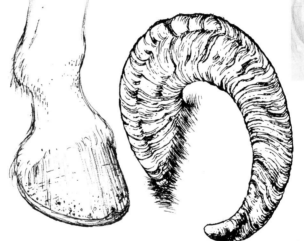

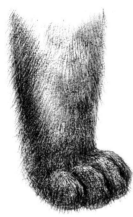

Horse's hoof and sheep's horn drawn with pens.

Squirrel drawn with fine technical pen and finished with diluted ink washes and touches of black crayon, giving the animal its typically furry look.

Bird's foot drawn with a brush and wash of watercolour.

Animal textures by Sally Michel.

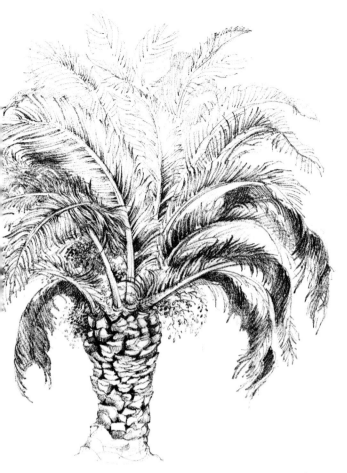

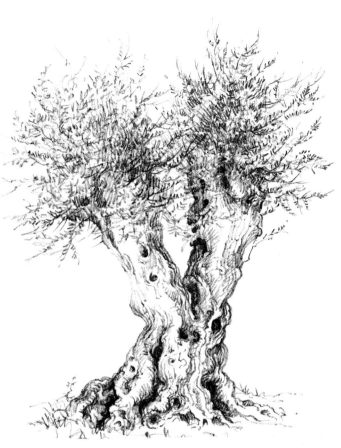

The wild date palm is a riot of textures, with its exuberant fronds, clusters of fruit and the hard, scaly trunk from which the stumps of cut fronds emerge. This was drawn in 6B pencil.

The old olive tree in 4B pencil, has the gnarled and twisted trunk characteristic of this tree, a shape which contrasts with the delicate new growth springing from the aged trunk.

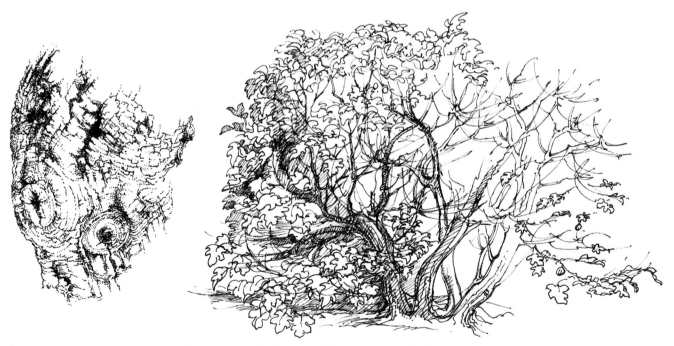

The fig tree is drawn quite loosely and expressively, providing a strong stylistic contrast to the detailed study of its bark. Both drawings are in felt-tipped pen.

Drawings by Margaret Merritt.

Drawing textures

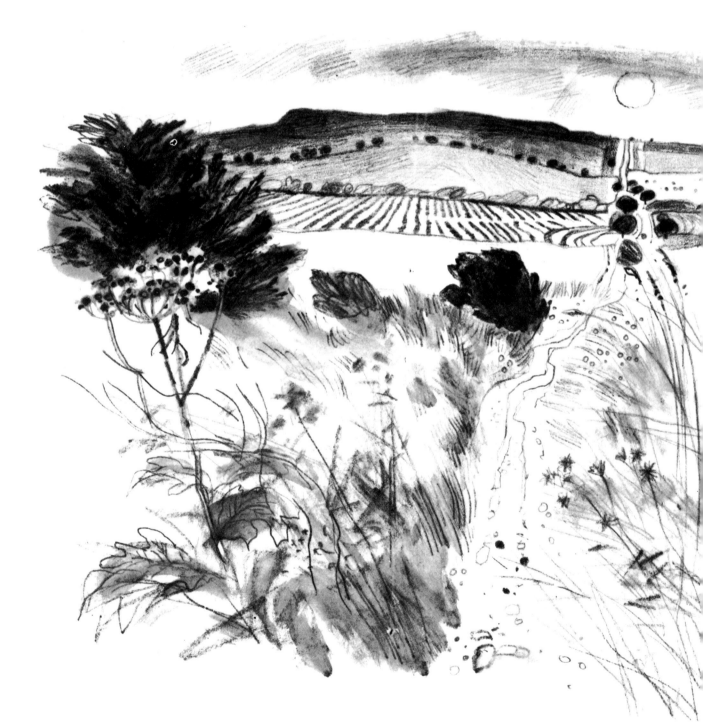

In producing this sketch, Clifford Bayly was preparing for a large painting to be produced later in the studio. He says, 'It required reference on tone and particularly texture. While working I was continuously discovering dynamic forms of contrast: linear forms against solid masses; small dark seed heads against soft areas of light grass; dark masses of bushes against light and strongly textured fields; small areas of detail set amongst open blank spaces. To do justice to the richness of this landscape I used pencils: HB for fine lines; 3B for heavier shading; black watercolour pencil for dark masses and wash areas – plus a liberal use of the thumb to soften lines and unify areas.'

Landscape by Clifford Bayly.

Using Line

The most commonly used and expressive mark in drawing is the line. Its simplest use is to define the edges of forms as you see them; in other words, their outer edges.

Take a drawing sheet and draw one object in front of another in lines of equal weight. Now go over the lines of the object in front, making them darker – and immediately it will appear nearer, even if the object is smaller. This is a simple demonstration of the expressive power of lines.

Clifford Bayly states, 'Constructing forms on paper with line is a most valuable skill – I call it a skill because it can be learned; it has nothing to do with talent or depth of expressive feeling. Using lines to give an impression of solidity and space is just a matter of simple observation related to a few basic rules and optical laws, which can be learned quite easily. The secret of success is to observe and practise drawing rather than make intensive study of the rules – draw first and consult the rules only when you get into difficulties, or when your drawing does not turn out in the way you have perceived your subject.'

Once you have acquired the skill of observational drawing, start to use line to express feeling and movement. A simple line of equal weight throughout its length may have a descriptive purpose. An expressive line can be straight or flowing, scribbly or jagged, continuous or broken. It can describe form by following it rhythmically, it can express tone by cross-hatching, it can portray stillness or movement through its dynamic quality. Within a single stroke it can become thick and thin, heavy or light. Lines can flow alongside each other, cross, or stop dramatically, almost touching each other.

Drawings by Clifford Bayly.

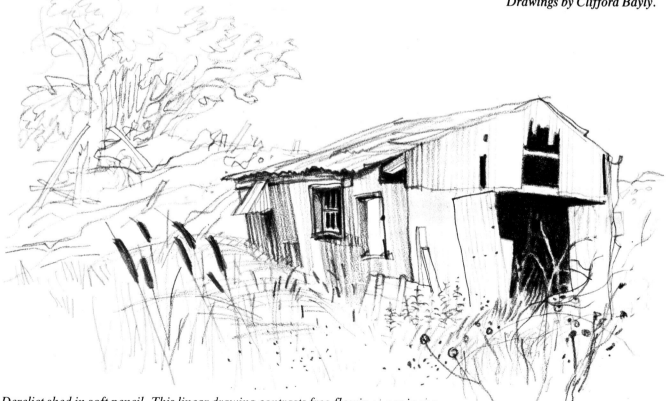

Derelict shed in soft pencil. This linear drawing contrasts free-flowing lines in the trees and grasses in the foreground with the geometric forms making up the shed. Tone is added sparingly to emphasize the abandoned nature of the subject.

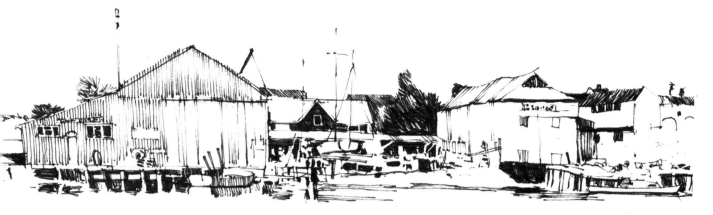

A linear study in fine pen and black ink. The dark areas are expressed with close lines.

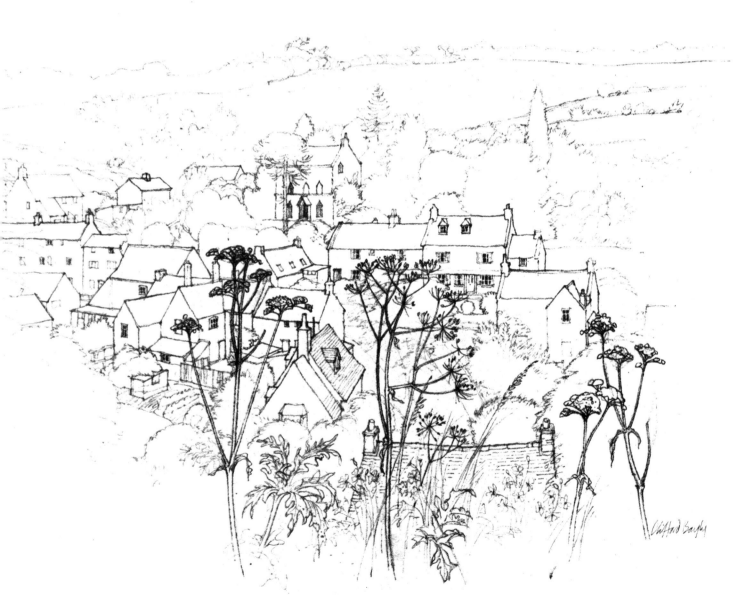

In this drawing, weight of line is used to create recession, the nearest objects carrying the darkest lines. When you have mastered tone, practise this kind of control leaving out blocked tone wherever possible.

Using line

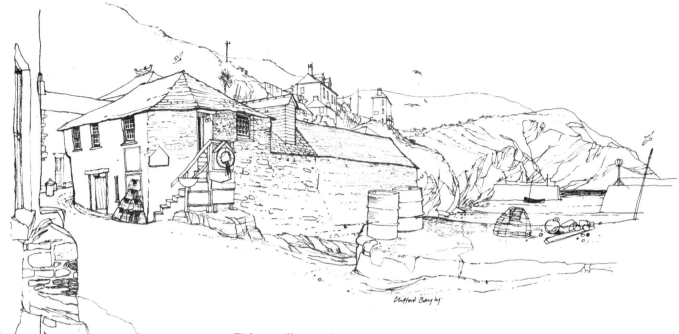

Fishing village in fine pen and ink by Clifford Bayly. By drawing just part of the cottage, the observer is led 'round the corner' of the road, which disappears over the hill through the houses in the middle distance. Such hints add to the interest of the drawing.

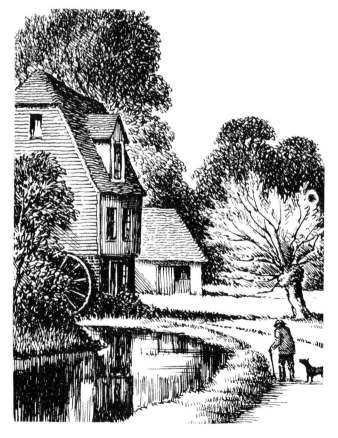

Sketch of a water-mill by Ray Campbell Smith.

Line drawing with indian ink has long been a popular method of illustration, much appreciated by printers, for the crisp, black lines are relatively easy to reproduce. It is a versatile technique, in that it can cope with a wide variety of tones and textures and is capable of rendering the smallest detail. It is particularly useful for small drawings, but rather less so for the larger variety. Ray Campbell Smith comments, 'I prefer to use a flexible nib, capable of producing both fine and thick lines. Fine lines are used for drawing and shading distant objects, as they produce a greyish effect which suggests recession. Foreground objects are treated more boldly with strong, black lines which bring them forward. Smooth papers are normally used so that the pen can glide over the surface, without snagging.

'The old mill house (left) is largely surrounded by foliage, the treatment of which has been varied to provide tonal contrast. Where the buildings are in shade, the foliage is comparatively light; where they are in sunlight, the tone of the foliage is much deeper. The small willow tree on the right is set against the darker trees beyond, again to obtain tonal contrast. The footpath carries the eye into the centre of the drawing and the old man is also moving into the scene, albeit slowly! The reflections in the water are built up with a series of vertical marks, to suggest still water.'

On the following pages you will find uses of observational, expressive and dynamic line, sometimes in combination, but all demonstrating many varieties of use to which line can be put.

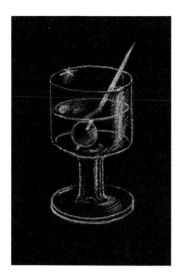

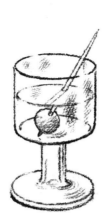

Sketch by Jack Yates, using flexible pen and black ink to give different weights of line within the same stroke.

White crayon on black paper and black crayon on rough-surfaced paper. Notice the variants in lighting the same object.

Nervous and sensitive broken lines capture an informal pose in this quickly executed fine pen and ink sketch. The mood is caught without faithful reference to form, although you feel its presence.

Drawings by Clifford Bayly.

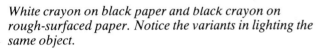

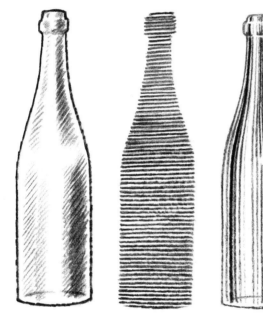

Bottles. Three observational studies using soft pencil line. The centre bottle is a silhouette. Try drawing the same object using different but purely linear techniques.

The use of wax crayon in carefully controlled horizontal and dynamic lines deliberately blurs the cyclist to give a vivid impression of speed and energy.

Using line

Drawings by Clifford Bayly.

Black ink applied freely with a brush on rough-textured paper produces a silhouette of the potted plant, yet this drawing is linear in application and effect.

Here, the artist draws in line, with the merest touches of tone – dried honesty in a kitchen jug.

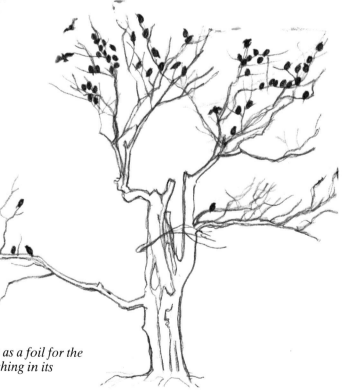

The tree, outlined in soft pencil, serves as a foil for the black marks depicting small birds perching in its branches.

Drawings by Margaret Merritt.

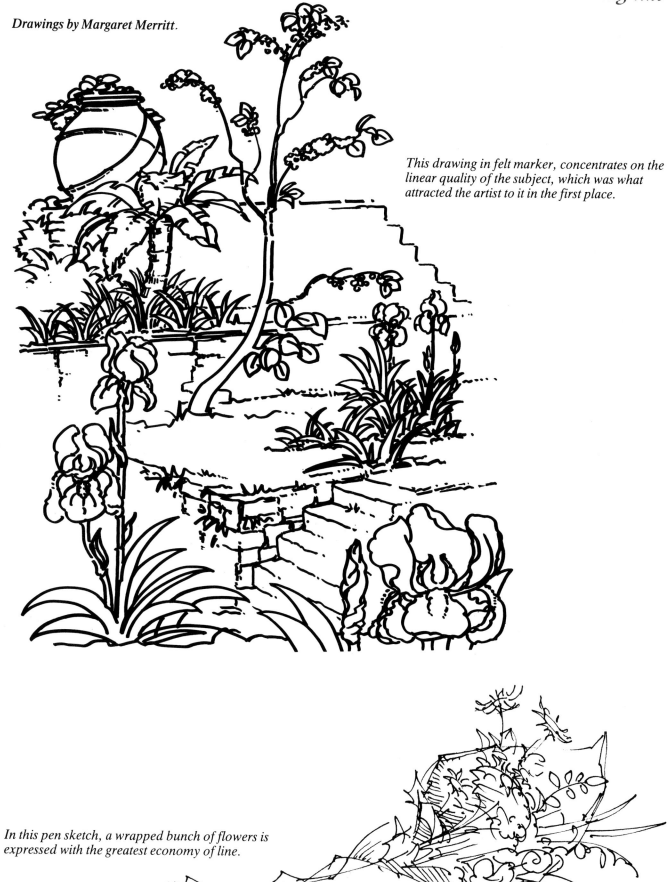

This drawing in felt marker, concentrates on the linear quality of the subject, which was what attracted the artist to it in the first place.

In this pen sketch, a wrapped bunch of flowers is expressed with the greatest economy of line.

Using line

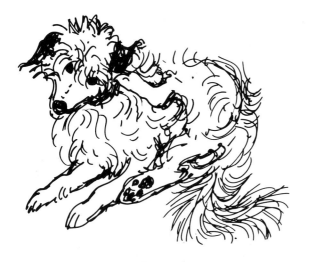

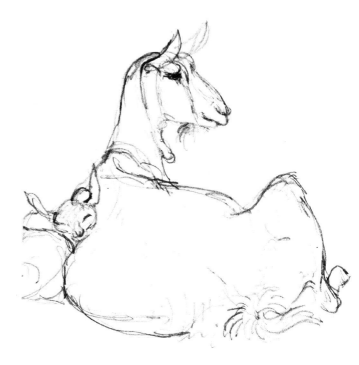

'My dog scratching'. A quick sketch executed in fine fibre-tipped pen.

A delightful study of a she-goat and her kids drawn in B pencil.

A lightning study of a cat about to pounce, in pen and ink. It took the artist five seconds. She comments, 'After years of experience, an artist may base his picture on a sketch so slight that it seems almost as if the drawing stage has been by-passed. For this to be done successfully, careful study and observation must have been carried out over many years, so that the artist's knowledge of the subject enables him to sum up very quickly the essential facts of the model before him and to add these to what is already in his memory.'

Drawings by Sally Michel.

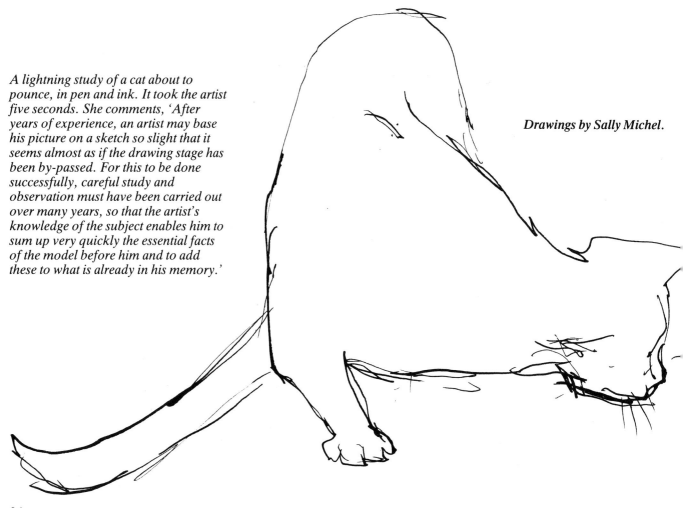

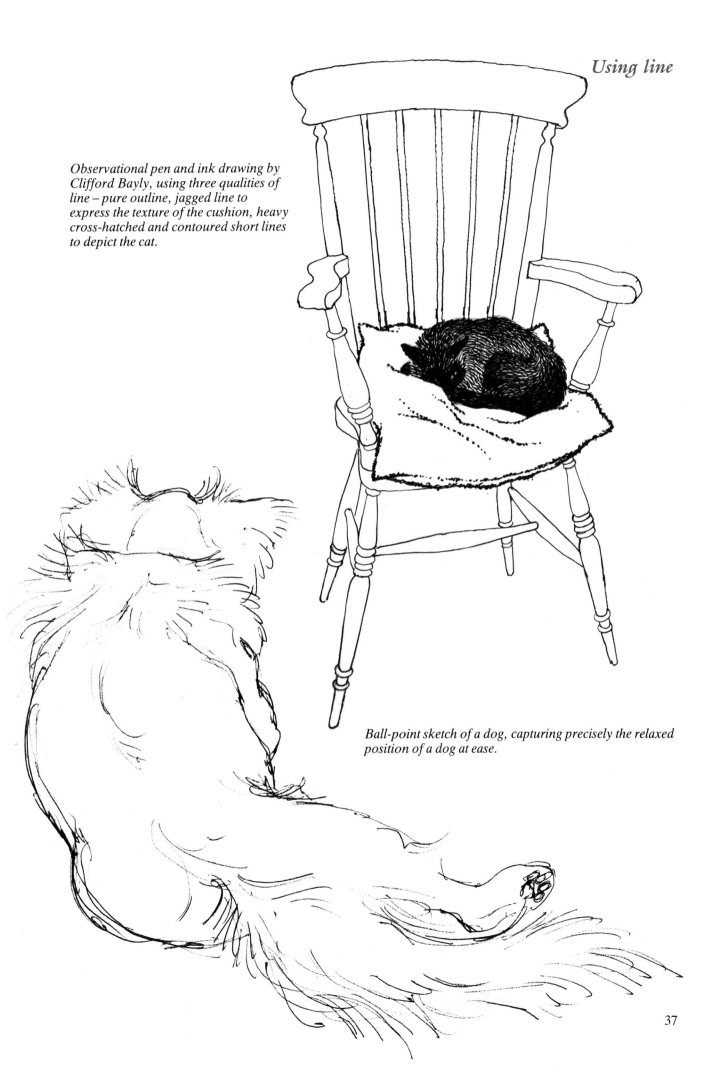

*Observational pen and ink drawing by
Clifford Bayly, using three qualities of
line – pure outline, jagged line to
express the texture of the cushion, heavy
cross-hatched and contoured short lines
to depict the cat.*

*Ball-point sketch of a dog, capturing precisely the relaxed
position of a dog at ease.*

Using line

Sketches of three feathers in ball-point pen.

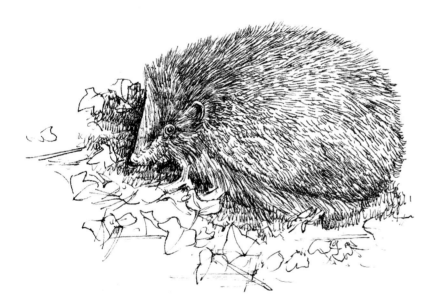

Hedgehog in pen and ink.

Drawings by Sylvia Frattini.

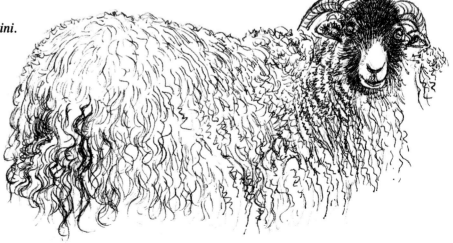

Fell sheep in pen and ink.

A nesting box with blue tits drawn with a fine technical
pen and black ink.

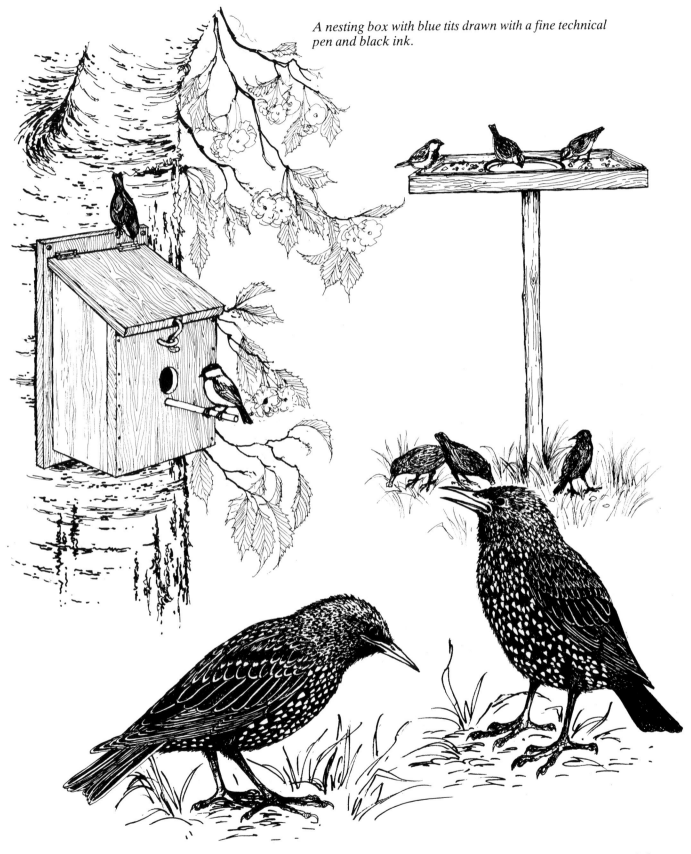

A study of starlings around a bird table in fine pen and fountain pen and black ink.

Drawings by Sally Michel.

Using tone

You have seen how line can build up your pictures. By adding tone, you can create still further the illusion of three-dimensional form or enhance a mood or an atmosphere.

Tone is the study and application of lights and darks; another word for it is 'shading'. As you see your subjects in colour, you have to make a mental adjustment when depicting tone, to translate the colour into darks and lights and observe within them highlights and shadows.

If this seems confusing at first, then look at your subject with your eyes screwed up. This will reduce the effect of colour and detail and enable you to see the tones more clearly.

Simple, short strokes or lines (cross-hatching) can build up form and from such applications you can go on to explore the whole range of tone-making. You can also apply continuous tone to a drawing in a dry or a wet medium, or both. On the page opposite, George Cayford has constructed an entire picture out of large areas of tone; there is hardly a line in his drawing of an interior by lamplight. To get this effect, he uses graphite powder worked in with his fingers and cotton buds, picking out the highlights with a putty eraser and adding to them with white pastel. This is an extreme example, and perhaps not to be emulated until the more conventional methods of drawing have been mastered, but it is very successful in its own way.

So you see that tone can be hard or soft, smooth or coarse and that with tone you can describe textures, such as a cat's soft fur, the naked shoulder of a woman, shiny leaves, the woven straw of a hat, rusty metal or stone and brick walls.

The paper you choose will have a significant effect on your drawing. Unless you are laying down washes of thinned ink to achieve tone, the grain or smoothness of the paper will affect the marks you make on it. (See the previous chapters on materials and marks.)

There are practical problems to be faced when you are

Drawings by Peter Caldwell.

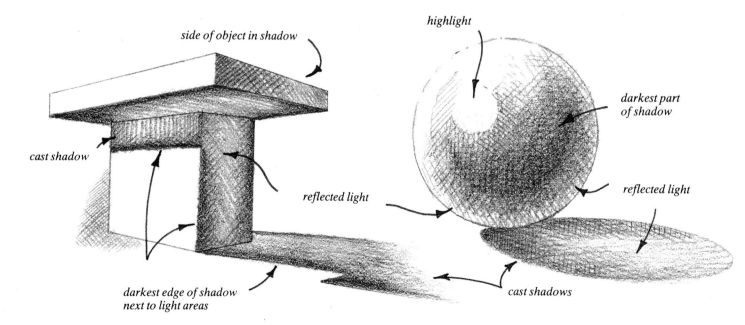

Light and shadow can be suggested, irrespective of what drawing instrument you use – pencils, charcoal, crayons or pen and ink, etc. Cross-hatching, shading and bare white surfaces add form and depth to pictures and shapes.

working with tone. Firstly, with dry media, there is the tendency for most of these to smudge. This should be seen, however, as a quality of these media which can be creatively exploited in your work. However, there are situations when it is necessary to keep the surrounding paper clean and confine the rich smudging and softened tone to very limited areas. Basically, this is achieved by simple common sense in using your media, such as working from left to right (if you are right-handed) and keeping any completed work under a cover of light smooth paper held in place temporarily with tabs of masking tape. Your experiments with various media on different papers, as suggested earlier, should now begin to relate directly to your developing drawing abilities. The samples of drawn objects overleaf show how appropriate media can not only help to suggest the character of the subject but have been drawn on the appropriate paper surface. For example, the pulley wheel block – while drawn with a fairly hard pencil (HB) so that the wood grain and smaller forms of the copper rivets can be represented satisfactorily – is drawn on a smooth hard cartridge paper. A rough-surfaced paper would destroy any fine work, however carefully drawn even with a well-sharpened pencil.

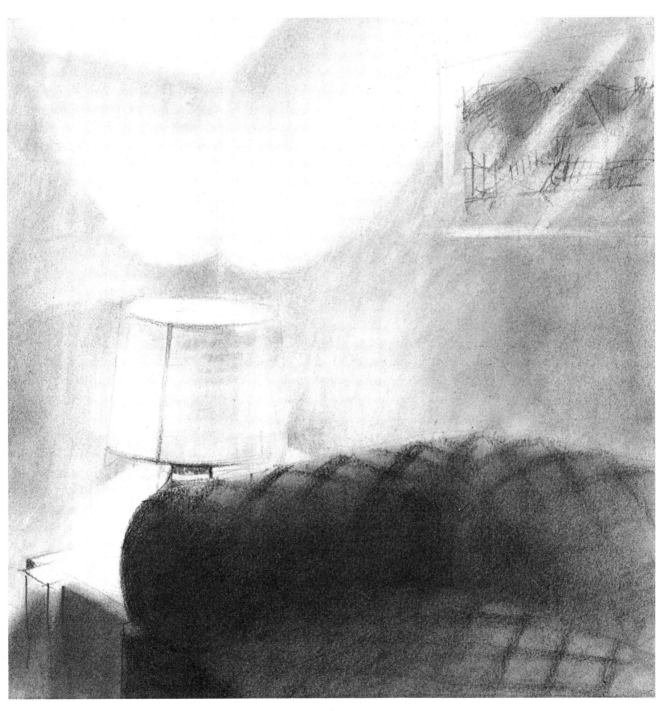

Interior by lamplight, by George Cayford.

Using tone

Of course, tone can be used to express mood, mainly in landscape subjects but also in drawings of interiors and in some figure work. Avoid attempting to cover large areas of the drawing, such as sky or water, with continuous tone. It is likely to make the work look heavy and dull and will tend to smudge and pull down the rest of the work.

Small areas of tone in carefully selected areas work best with strong emphasis only in the deepest shadows. Practise a series of small tonal landscape drawings of a simple subject but try changing the tonal pattern in each. For instance, in one the sky could be light and the land mass middle-grey with small dark objects in the foreground; while another could have a middle-grey sky with a light land mass and dark foreground objects – variations ad infinitum.

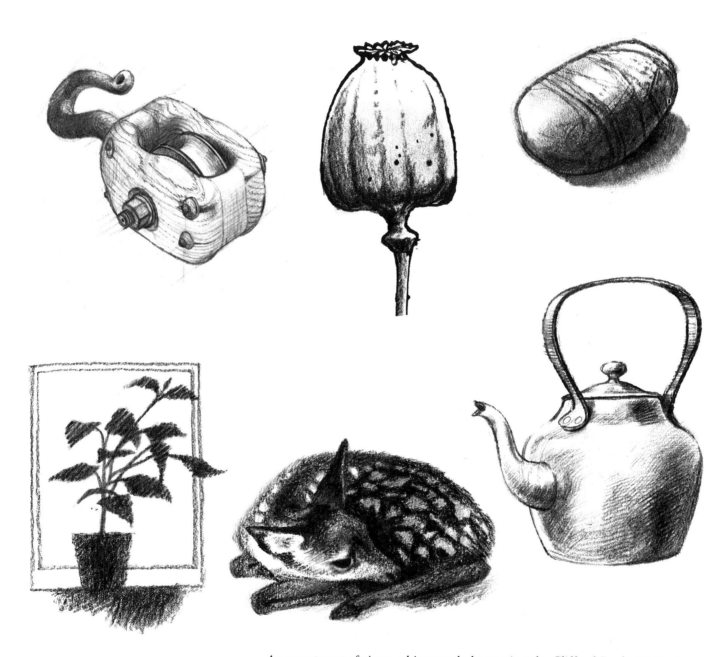

An assortment of views, objects and observations by Clifford Bayly. Notice how each drawing has its appropriate texture for wood, material, stone, plant, fur and metal.

Peter Caldwell is a master of light and shade, and he writes, 'Make good use of light and shade. Exploit them, even exaggerate them, for they can make an otherwise ordinary drawing into something special. To me, dark shadows and contrasting lighter areas create the magic that transforms a mundane drawing into a picture full of interest and appeal.

'Having stressed the importance and beauty of shade, I find that the best way of actually drawing shadows using pencil and pen, is with cross-hatching. This technique allows you to overlap lines to create varying degrees of shade and it gives an illusion of depth. Broader drawing tools, such as crayons or brushes, can be used to create the same effect – shadows and shading are achieved by using broader strokes.

'Horizontal, vertical and diagonal strokes can also be used effectively, as can dark areas with very little detail. Contrasting shadows heighten the drama and appeal of a scene.'

Caldwell's observations on light and shade may at first seem to over-complicate what to most people is a simple matter of black and white. 'But', he continues, 'from personal experience I have found it is worth the effort to pay it a little attention. It is a crucial factor in the build up of a picture.

'There are certain points to remember when tackling areas of light and shade:

1. The lightest lights occur next to the darkest darks.
2. Sunlit areas do not show much texture or detail, whereas shadowed areas show plenty of detail. When drawing in shadows the texture and detail should be combined with plenty of cross-hatching.
3. In bright sunlight the cast shadow is darker than the object in shadow.
4. The shadow cast by an object will follow the contours of the ground or whatever surface the object is standing on. This can offer a variety of dramatic and exciting patterns.'

Cross-hatching by Peter Caldwell. A clear wash brushed over fibre-tipped pen creates a lovely warm effect.

Hatching.

Cross-hatching.

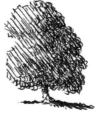

Shaded foliage.

Curved hatching.

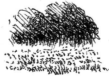

Grass.

Examples of hatching by Ray Campbell Smith.

43

Using tone

The following drawings by Peter Caldwell demonstrate several of the points he makes about tone.

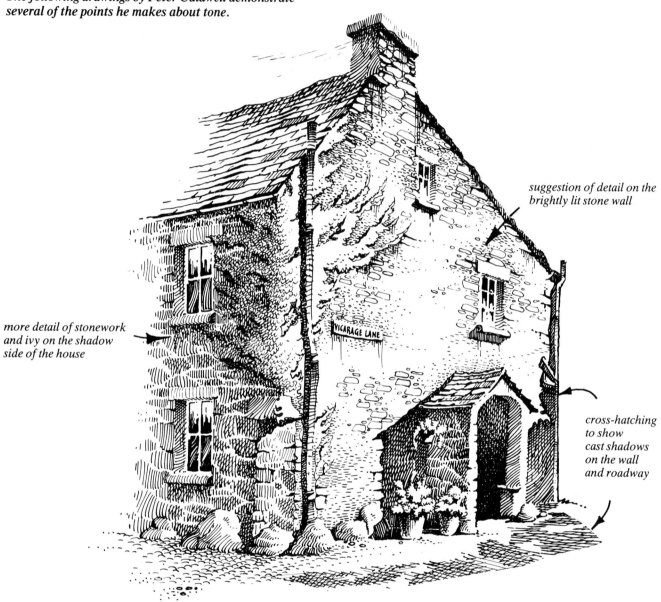

suggestion of detail on the brightly lit stone wall

more detail of stonework and ivy on the shadow side of the house

VICARAGE LANE

cross-hatching to show cast shadows on the wall and roadway

In this drawing, lightest areas appear next to the darkest darks, the sunlit areas do not show as much texture and detail as the shaded areas. Note also the use of cross-hatching.

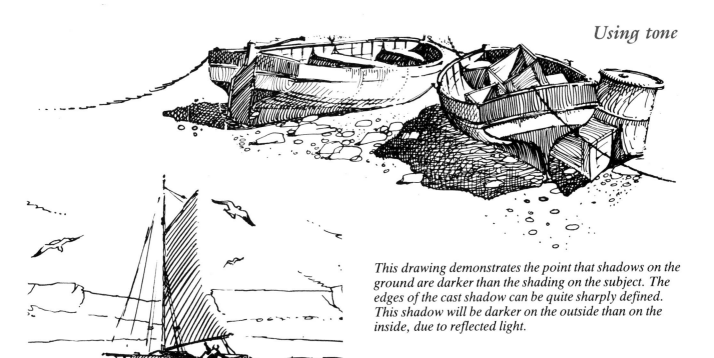

This drawing demonstrates the point that shadows on the ground are darker than the shading on the subject. The edges of the cast shadow can be quite sharply defined. This shadow will be darker on the outside than on the inside, due to reflected light.

A few simple lines can give an impression of light and shade.

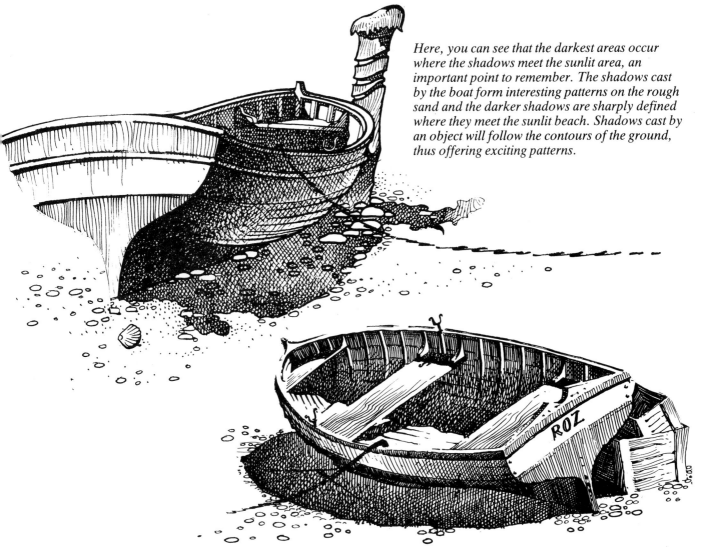

Here, you can see that the darkest areas occur where the shadows meet the sunlit area, an important point to remember. The shadows cast by the boat form interesting patterns on the rough sand and the darker shadows are sharply defined where they meet the sunlit beach. Shadows cast by an object will follow the contours of the ground, thus offering exciting patterns.

45

Using tone

In this pen and ink drawing by Peter Caldwell, strong dark shadows are again used in stark contrast to the glaring white of sunlit buildings. Bright sunlight tends to glare on plain surfaces, thereby cutting down on the amount of textured detail you would normally be able to see. In these highlighted areas, therefore, you should only suggest detail. Conversely, the shadowed side of an object, a wall for example, shows a lot more detail, plus areas of deeper shade which can be illustrated by cross-hatching.

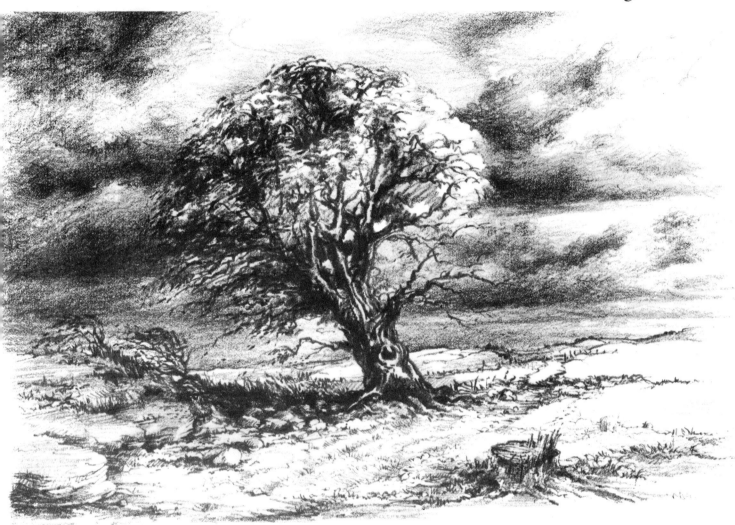

Storm over an old oak, by Margaret Merritt. A fitful sun strikes the right hand of the tree, giving contrast to the lowering sky. This picture evokes mood and atmosphere by exploiting light and dark contrasts, which contribute to the unity of the whole.

This tonal study by Clifford Bayly shows the dramatic use of silhouette, with light falling across the table in front of the seated figure, on to the table and the vase of flowers.

The figure and the chair form the dark silhouette against a light window, while the flowers and table top form the light silhouette against the darker wall in shadow. This form of visual relationship is known as 'counterchange' and is found continuously in nature and in the work of all artists.

A secondary silhouette is formed by the far chair and the pots on the table. The whole composition is softened by the use of intermediate tone in the curtains, flowers and gradation of wall shading.

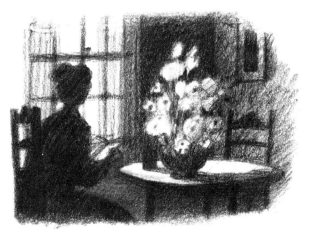

Using tone

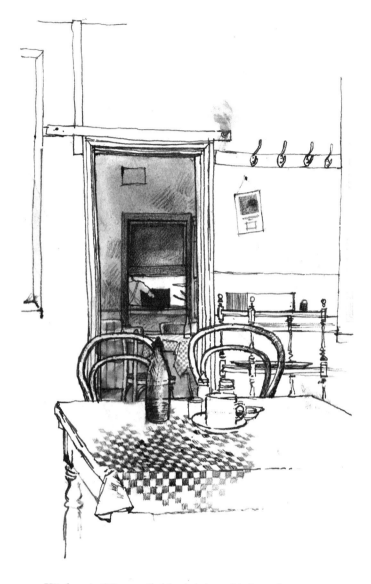

Drawings by Clifford Bayly.

Cat at the window. Notice how the balcony railings change from positive shapes (left) to negative ones (right) as the tonal background changes.

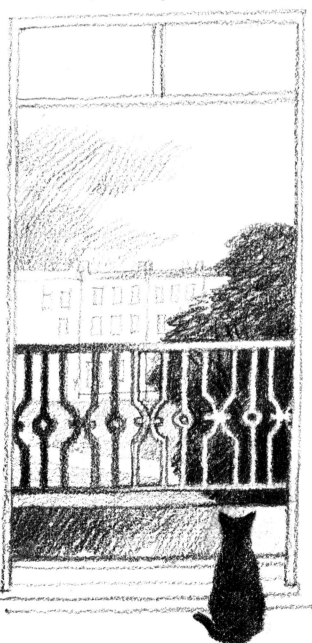

Kitchen in 2B pencil, black ink and ink washes on cartridge paper. Here, counterchange exists but falls within itself: white wall with the dark silhouette of a large doorway which contains within it a further doorway beyond which a light silhouette frames further dark shapes. The table uses a pattern to contrast with the light wall areas, while a sauce bottle and mug offer a dark and light shape respectively.

Cat on the mat, by George Cayford. This has been drawn in 7B pencil rubbed with the fingers, with a putty eraser used to pick out the highlights.

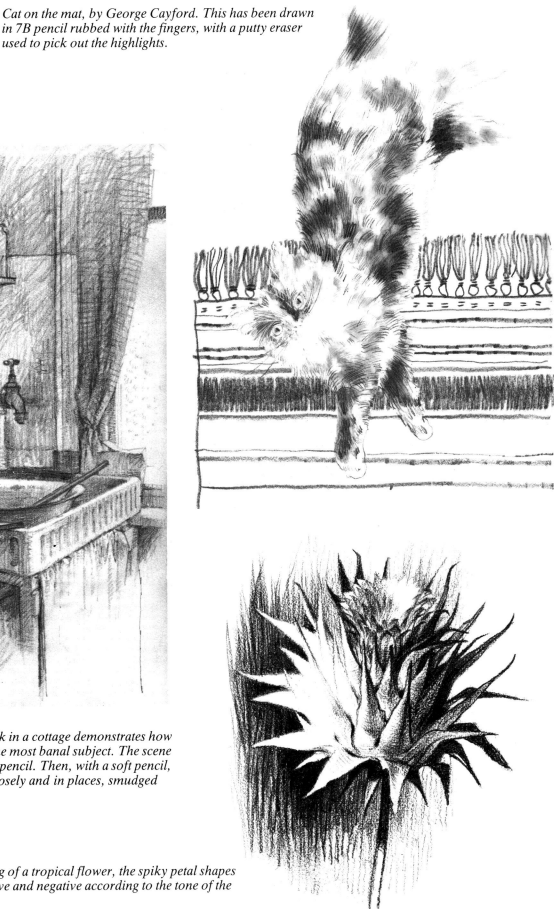

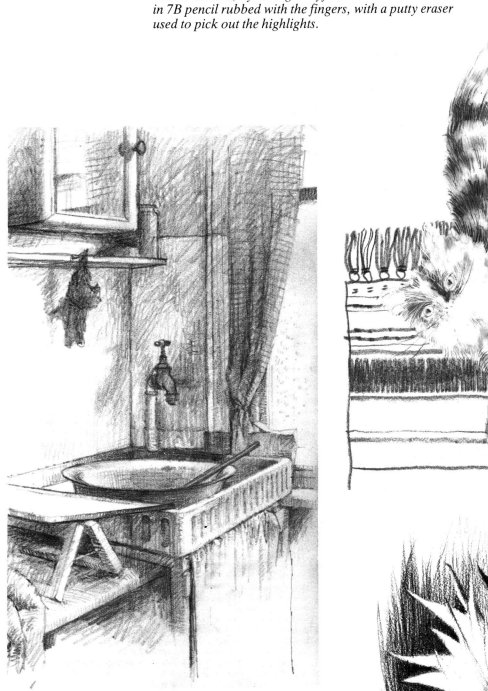

A study of a kitchen sink in a cottage demonstrates how tone can enliven even the most banal subject. The scene was first drawn in hard pencil. Then, with a soft pencil, the tones were added loosely and in places, smudged with a finger.

In this drawing of a tropical flower, the spiky petal shapes become positive and negative according to the tone of the background.

Perspective

You need to understand about perspective for most kinds of drawing, not just for buildings but for figures, landscapes, animals and plants – even a piece of fruit needs to be drawn in perspective.

What is perspective? The dictionary defines it as 'the art or science of drawing objects on a surface, so as to give the picture the same appearance to the eye as the objects themselves', or, to put it another way, it is the 'representation of appearance, of objects in space, with effect of distance, solidity, etc.'

Once it has been explained, and after a little practice, it is not all that difficult to master, although as Ray Campbell Smith says, 'Many people experience great difficulty with perspective and often allow faults to persist in their work long after they have left other elementary mistakes behind them. This is unfortunate, for mastering the rules of perspective is not a difficult matter and once this has been achieved, the problems disappear. A knowledge of perspective is not so vital in drawing such objects as trees and fields, but buildings, bridges and roads occur in landscape subjects and here an understanding is essential. Even cloudy skies are subject to the laws of perspective and you need to know enough to avoid drawing rivers that appear to flow uphill!

'Perspective is based upon the observable fact that objects appear smaller the further away they are and that beyond a certain point they disappear altogether. This is shown diagrammatically in Fig. 1, in which the line of telegraph-poles seems to disappear at the point on the flat horizon, known as the "vanishing-point".

'In Fig. 2 there are two vanishing-points on the true horizon, or at eye-level. Notice that this is not concerned with the observable horizon which may well be modified by rising ground. Only in the case of the sea, or a dead level plain, will the true and the observable horizons coincide.

'Fig. 3 demonstrates how much steeper the perspective lines are when the object in question is close at hand and how much flatter they are when it is further away. In Fig. 4, you can see how objects that are not parallel have different vanishing-points.

'The perspective of reflections often causes difficulty; the trick here is to imagine the flat plane of the water surface continuing right to the foot of the object reflected, and the construction in Fig. 5 indicates how much of the reflection you will see. Finally, the construction in Fig. 6 tells you how to determine the size and position of cast shadows.

'With practice, perspective becomes intuitive but until that happy day these constructions will enable you to check your drawings against gross error.'

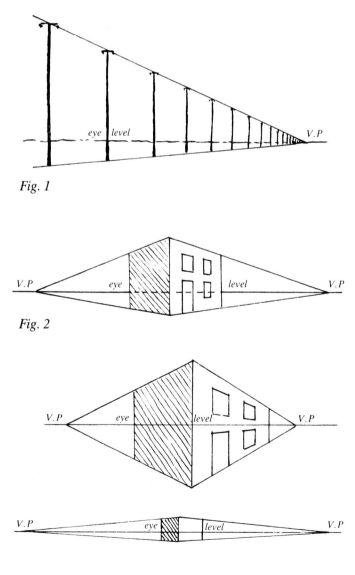

Fig. 1

Fig. 2

Fig. 3

Drawings by Ray Campbell Smith.

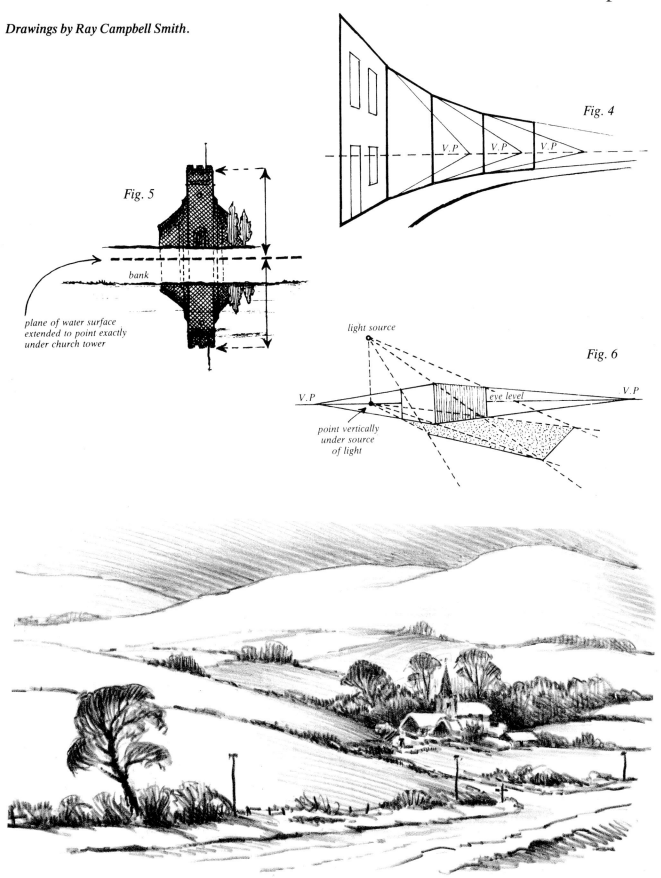

Fig. 4

Fig. 5

*plane of water surface
extended to point exactly
under church tower*

bank

light source

Fig. 6

V.P

eye level

V.P

*point vertically
under source
of light*

*The telegraph-poles in this sketch are obeying the laws of perspective: they
diminish in size as they travel further away from the viewer.*

Perspective

Fig. 1a

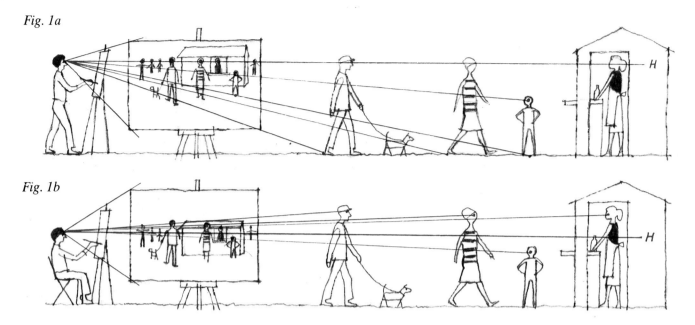

Fig. 1b

Perspective in buildings

A knowledge of perspective is particularly important when drawing buildings. The height from which you look at your subject, i.e. standing or sitting, will produce two completely different views. The illustration above shows how other people of similar height to yourself relate to the distant building and to the horizon.

Standing height (Fig. 1a) gives a high horizon with the eye-level of each standing adult, similar to your own, level with the horizon. This is because the horizon line always coincides with the eye-level of the artist – the most basic law of perspective. Sitting height (Fig. 1b), therefore, presents a lower horizon, with standing figures well above the horizon level. The sight lines of the artist are projected through the 'picture' to the subject-matter to demonstrate these points. The child's

height, which is that of the sitting artist, coincides with the horizon.

Vanishing-points

Having established your horizon or eye-level, you now have to determine the point on the horizon towards which parallel lines appear to converge. A good example of this can be found in any straight level road or street. The examples here show that all horizontal lines running down the length of the street – such as kerbstones, roof ridges, roof gutters, tops, bottom and horizontal glazing bars – all appear to vanish to the same point on the horizon, whether at a high or low level or if they protrude forwards or lie back from the road. This rule applies in both Figures, although there is a higher horizon in the top example as seen from a standing position and then from a sitting position in the lower.

Fig. 2a *Fig. 2b*

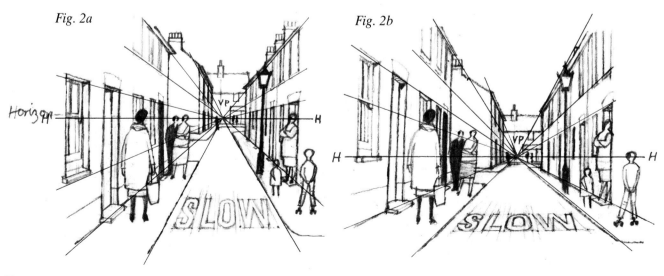

Fig. 3

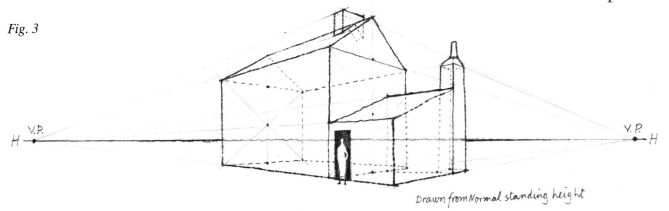

Drawn from Normal standing height

Notice (Fig. 2a) as in the eye-level diagrams, how the eyes of the pedestrians on the pavement coincide with the horizon and your own eye-level. This is not so when sitting to draw (Fig. 2b) as their common eye-level will appear horizontal and coincide with the horizon.

You may confront a building or group of buildings 'corner-on'. Here, you will find that, although those horizontal lines still follow the same rules, converging away to the horizon, those higher than your eye-level move downwards towards the horizon and those below eye-level move upwards towards the horizon. In this situation, you need two vanishing-points (Fig. 3) – both on the same horizon, each relating to the two sides of the buildings.

Roofs present a challenge as their angles vary and they do not conform directly to the previous 'rules'. Find the centre line of the gable wall of the building by drawing two straight lines diagonally from corner to corner on this wall. Where they bisect each other is the centre. Draw a vertical from this point upwards to the roof ridge and complete the roof (Fig. 4).

More complicated roofs are best rendered as a basic roof with sections removed or added (Fig. 5).

Where units are of the same height and equidistant from each other: the fronts of terraced houses, lampposts, fencing posts, etc., you can construct them by using an extension of the principle used in Fig. 4. Having established the height and intervals between the first and second units, find the centre of the height on the near object and project this to the appropriate vanishing-point on the horizon. This line will run through the centre of all other objects. Now draw a line diagonally from the top of the first unit downwards to the point where the centre line runs through the second unit. Continue this line from this centre point to the line which runs through the base of each object and you will have found the point on which to construct the next unit (Fig. 6).

Fig. 4

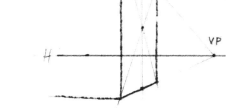

Fig. 5

Fig. 6

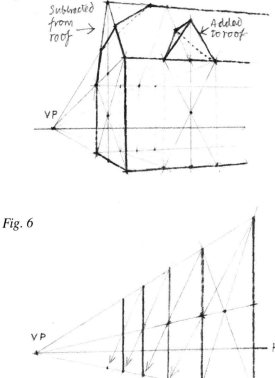

Drawings by Clifford Bayly.

53

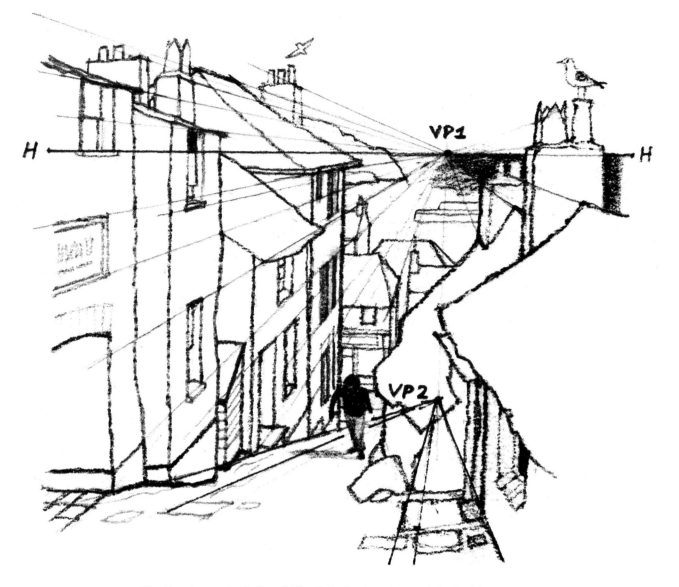

Fig. 7a. As you look downhill, all the horizon lines of the buildings converge along eye-level (H) at vanishing-point VP1, while the street surface lines converge at VP2.

Very high or very low viewpoints

Now look at some more extreme variations of eye-levels, bearing in mind the same principle of the horizon with your rising or lowering eye-level.

One of the most problematical viewpoints for the beginner is to draw a street which runs up or down a steep hill. These buildings step up on each other, therefore, a shop three or four buildings on up the hill may have its base level with the top of the ground floor

door of the lower one. Whether you can see the distant horizon or not you have to place a 'horizon' at your eye-level (H).

Downhill If you draw your base line for each building towards your vanishing-point (on the high horizon) you will find that you will also have to follow through with all the other lines on the same building and then so on up or down the hill from where you have chosen to start.

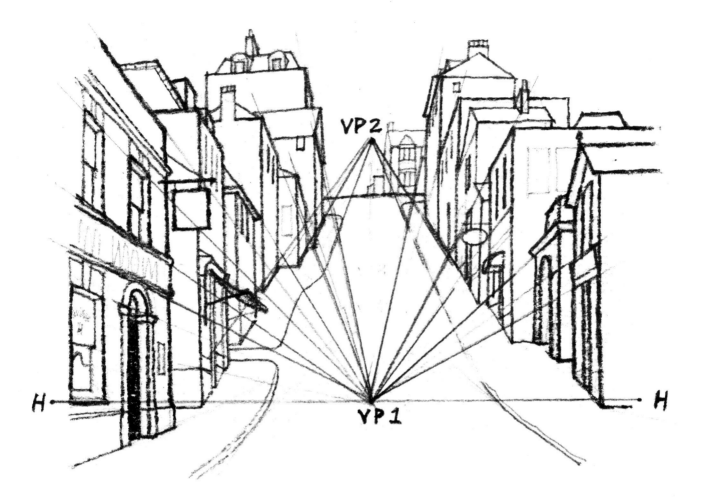

Fig. 7b. As you look uphill, the horizontal lines of the buildings converge along eye-level (H) at vanishing-point VP1. The street lines converge at VP2.

However, the sides of the street itself travel upwards or downwards (not parallel with the base of the building) and require their own vanishing-point on their own horizon (Fig. 7a).

Uphill The same principles apply to a subject where you are looking up a steep hill – where the horizon for the buildings will be low (level with your low eye-level) and the horizon for the street itself will be much higher. In both views the 'stepping' of the buildings will appear quite strongly pronounced as the buildings are fore-shortened (Fig. 7b).

A simple viewfinder or grid can be helpful provided that it is held horizontally when you are checking.

Remember, if your drawing 'looks wrong', keep checking the points discussed previously and you should find with careful observation and common sense that it will come out right in the end!

Drawings by Clifford Bayly.

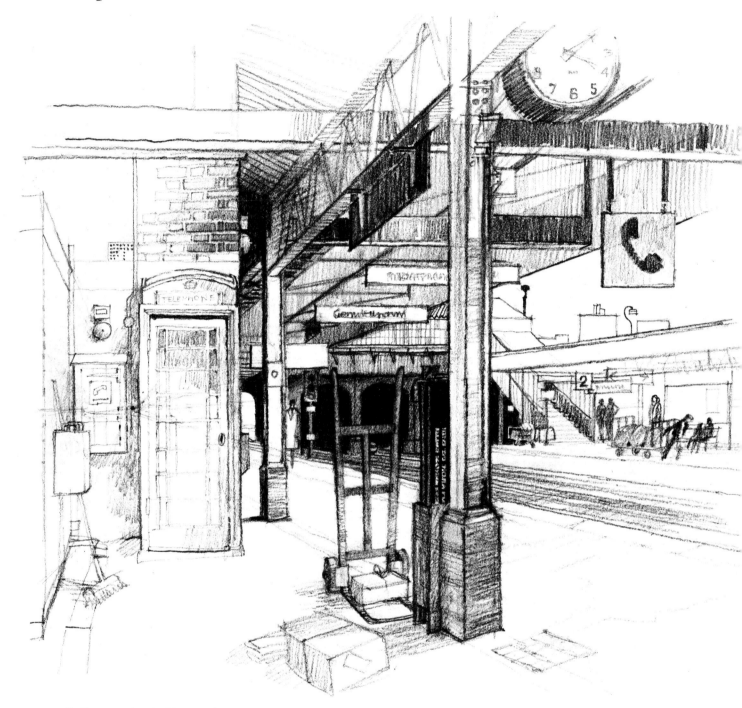

Railway station in 2B pencil with carbon crayon, by Clifford Bayly. This view is composed entirely around a single vanishing-point, situated just to the left of the telephone box. Notice that the perspective guide-lines have been left showing. There is an abundance of detail, but the drawing's interest lies in the dynamic of the perspective.

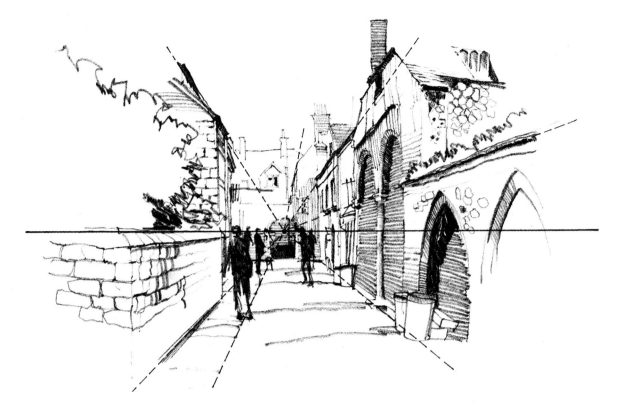

A pencil drawing by Richard Bolton, with perspective lines drawn in directly on the drawing. Notice that the horizon line is at the eye-level of the figures; the perspective of the street radiates below and outwards from the vanishing-point.

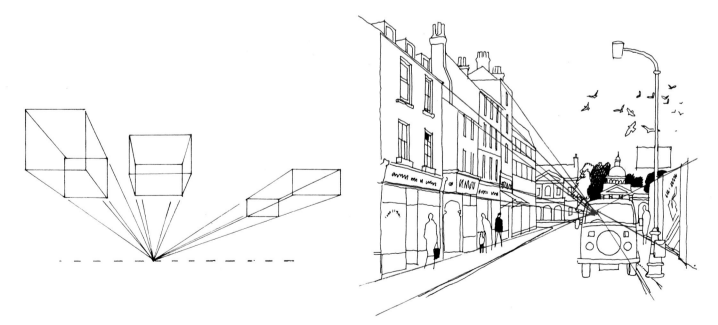

A diagrammatic illustration of a single vanishing-point perspective by Richard Bolton, and a straightforward street scene illustrating this by Clifford Bayly.

Perspective

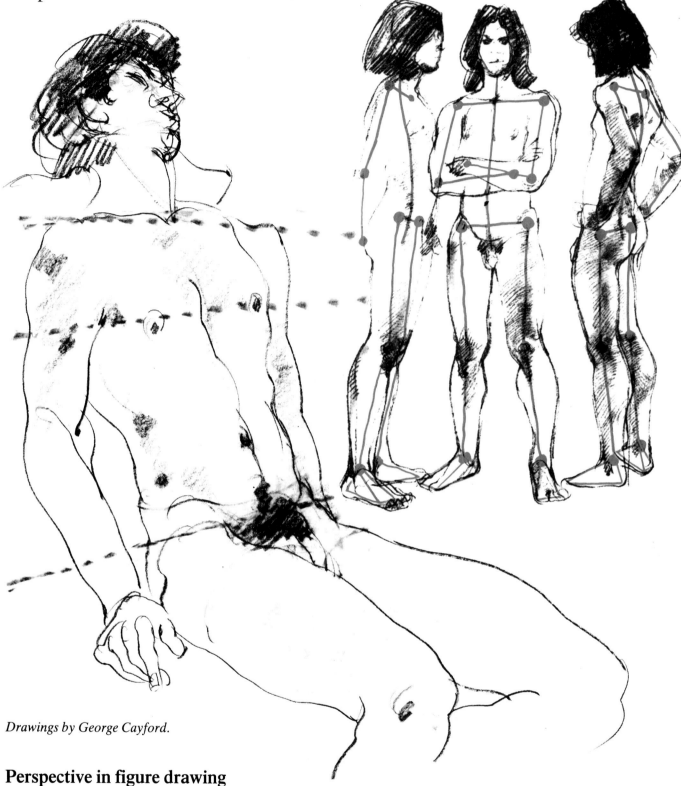

Drawings by George Cayford.

Perspective in figure drawing

The human body also obeys the laws of perspective, and George Cayford's figure drawings above demonstrate the point clearly. He says, 'The seated figure with the head thrown back has its hips, chest and shoulders all parallel, but my viewpoint of it made me realize that the parallel lines would have to obey the rules of perspective if my sketch was to look convincing.'

In a foreshortened pose, such as the one opposite by Jack Yates, those parts closest to you, obeying the rules of perspective, will always appear larger in proportion to those furthest away from you.

The little drawings of hands and feet opposite also demonstrate this rule. Notice how in the rear view of the foot (bottom), the toes almost appear to be going uphill because the artist was looking directly down on the foot. In the same view above it the model was standing on his toes, which altered the appearance of the foot considerably.

58

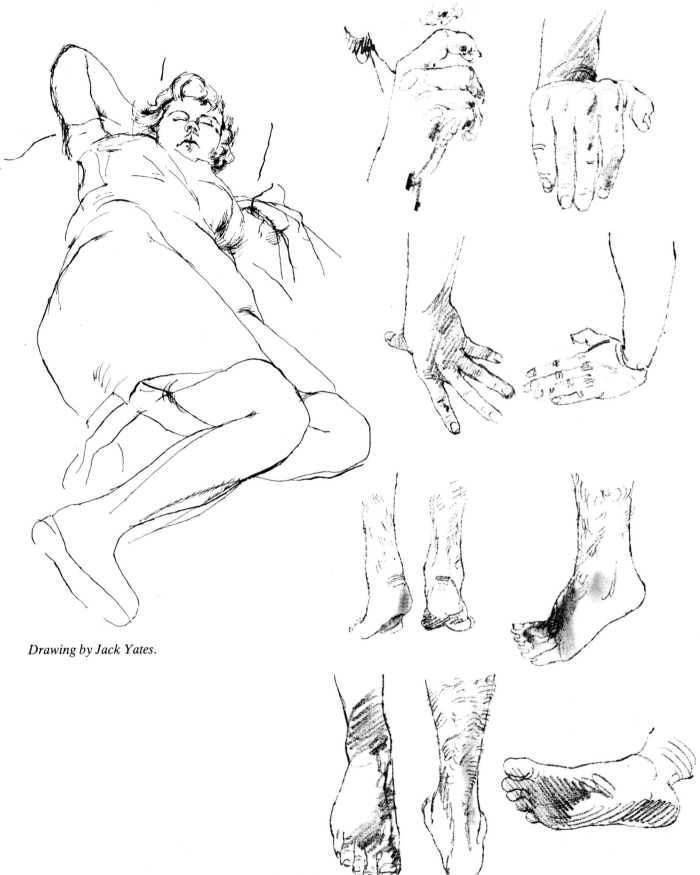

Drawing by Jack Yates.

Drawings by George Cayford.

Composition

The concept of good composition is a somewhat vague one and it is easier to recognize a well-composed drawing than it is to rationalize its success. Suffice to say that a drawing that has good composition is one in which the subject-matter is so arranged that the overall effect is pleasing and satisfying.

Artists came to believe that their rectangular canvasses could be divided up horizontally and vertically in an ideal manner and that if the main elements of the drawing fell on these divisions, perfect proportion would result. This theory was formalized in the invention of the 'golden mean', or 'divine proportion', as it was sometimes termed.

Ray Campbell Smith explains, 'To divide a line of any length into this ideal proportion, a geometric construction is necessary (Fig. 1). The line A to B is extended by half its length to C and a vertical line A to D, equal in length to A to B, is drawn from point A. With the point of a compass on C as the centre, and C to D as the radius, describe an arc to cut A to B at point E. Point E now divides the line A to B in the ideal proportion. By producing line A to B to the right instead of the left, and using the same method, a second point, E1, will be found which also divides the line in the ideal proportion.

'Fig. 2 shows a rectangle ABCD in which all four sides have been divided up in this way and the resulting points are marked, E, E1, E2 up to E7. The lines joining the opposite points E indicate the golden means of the rectangle. The artist will try to place the salient features of his painting on these lines, to achieve compositional harmony.

'If all this seems Greek to you, and if the standard of your geometry is not up to that of your art, then you may find it easier to recognize the most common faults in composition without reference to Euclid. Here, then, are some of the pitfalls to avoid:

1. Avoid placing a dominant horizontal or vertical line right in the middle of your paper, dividing it into exactly equal halves.
2. Avoid placing a dominant line, such as the edge of a road, in such a manner that it originates in one corner of your paper.
3. Avoid placing all the tonal weight on one side of your paper.
4. Avoid making unrelated lines coincide. For example, do not let the ridge of a roof exactly coincide with a line of distant hills.

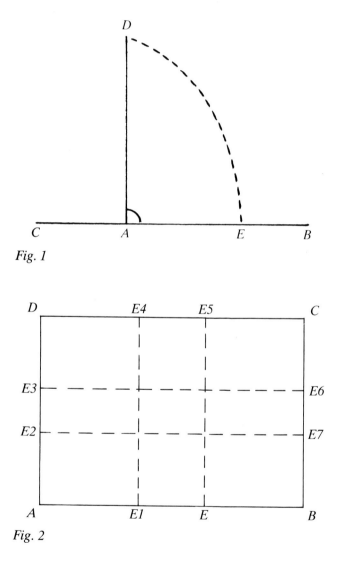

Fig. 1

Fig. 2

5. Avoid including, uncritically, every object, however inharmonious, in the view before you. A long line of regular fencing, for example, is best omitted, or at least modified.
6. Avoid drawing figures, vehicles, boats, etc., which are moving out of the drawing, for they carry the eye out of the picture instead of into it.

Fig. 3

Fig. 4

'These faults all occur in the rather unattractive Fig. 3 and are corrected in Fig. 4 in which, incidentally, the church spire is placed on the "golden mean"! Another common fault, which I could not squeeze into Fig. 3, is that of having two focal points instead of one – a forking road leading the eye to two competing centres of interest would be an example of this.

'With increasing experience, pleasing composition will in time become second nature. It is always good practice to make several quick sketches of your chosen subject, from varying viewpoints, before finally deciding upon your composition. This will exercise your critical faculties and increase your awareness of the dictates of sound composition.'

Two sketches by Ray Campbell Smith in which the faults mentioned here do not occur.

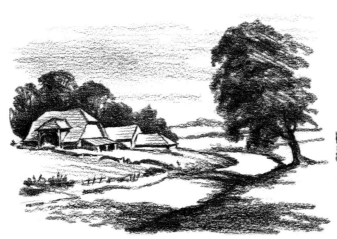

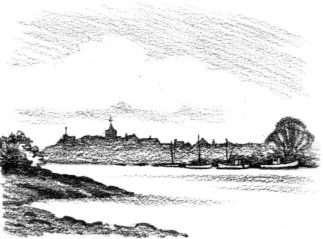

The lane carries the eye into the heart of the drawing. The sunlit roofs stand out against the darker trees behind and the nearer tree on the right helps to provide a tonal balance. The deep shadow of a tree just out of the sketch to the right provides some interest and tonal contrast in what would otherwise have been a rather flat and uninteresting foreground.

The lines of the river banks do not emanate from the corners of the paper, and the river is prevented from carrying the eye off the paper by a group of bushes on the left, which act as a buffer. The eye moves comfortably from the sky, to the buildings, to the boats on the right, to the bush on the left, and then to the rocky foreground.

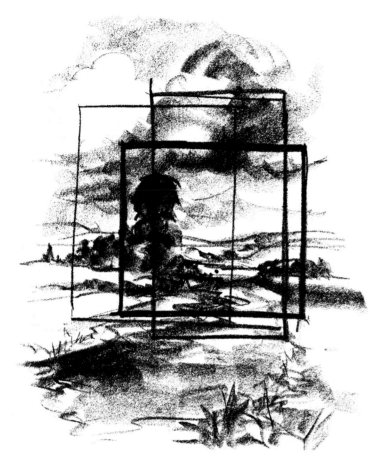

From the roughest of sketches in carbon crayon, the artist draws approximate rectangles and squares over it like windows, to determine the most satisfactory composition.

Composing landscapes

If you judge by the number of images, whether created by artists or by the camera, that appear in exhibitions or periodicals, then landscape is the most popular subject people choose to look at. Maybe that is because most of us live in towns – there is something refreshingly 'escapist' about the rural scene, and 'a weekend in the country' is what many of us dream about and only occasionally achieve. Such opportunities present the artist with a never-ending source of subject-matter, from vast panoramas to the intimate details of trees, plants and flowers.

Margaret Merritt writes, 'The movement of sky and ever-changing light demands a flexible attitude to technique when depicting landscapes, and you have to cultivate not only speed but a range of approaches to drawing to help you translate what you see into a sketch, picture or study.

'Many people use photographs to draw from in preference to working out-of-doors. Interesting work can be produced in this way, but for many the act of drawing outside in all weathers gives much greater satisfaction and interest.

'The vitality of a drawing depends on your spontaneous reactions to what you see. Your interest and feelings unite you to your subject and this gives your drawing life and meaning.

'Some artists develop sketches into highly polished drawings, others use them as the basis for painting. Whatever your motive for drawing, the materials you use must be understood and used with ease and confidence.'

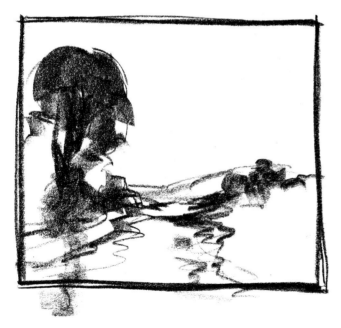

Another simple drawing of the one most heavily marked.

Sketches by Margaret Merritt showing how to compose a simple landscape.

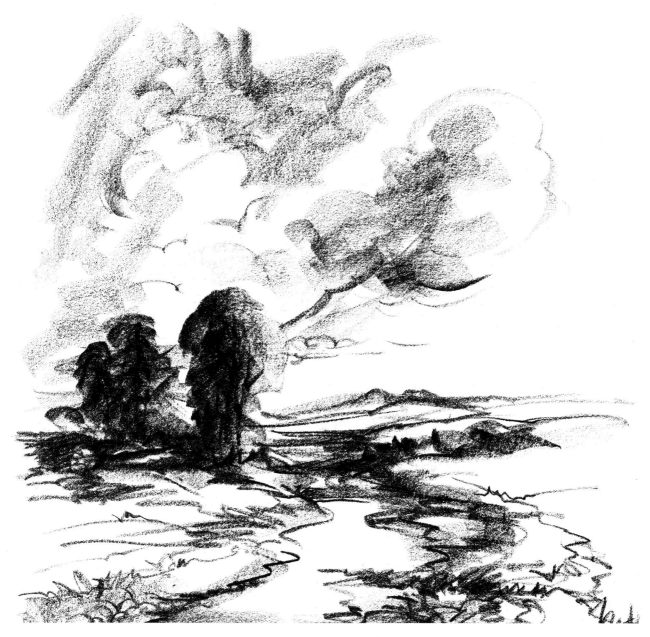

Finally, the artist compromises with the most finished sketch. Do not worry about wasting paper – make as many sketches as you need to find the composition you want.

Composition

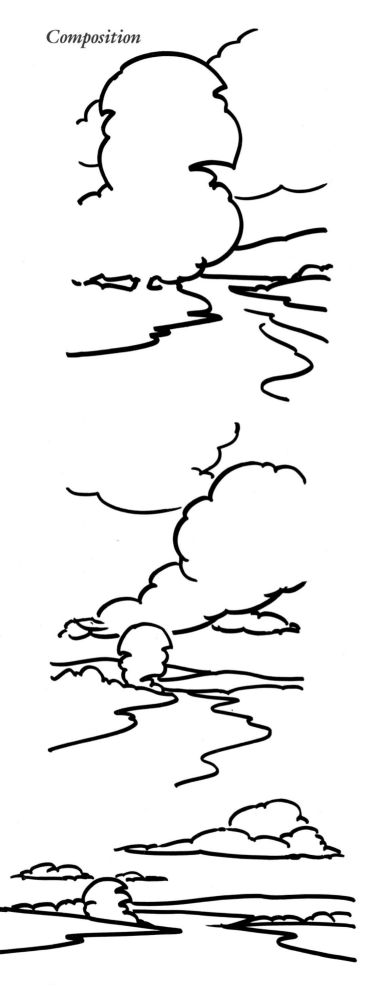

Merritt continues, 'Composition sometimes causes confusion amongst beginners who say "I drew it like that because it was there". By "composition" we mean how we organize and design a picture in relation to the space available.

'Composition must be determined by what you want to depict or illustrate in your painting. It is important to consider mood, atmosphere and impact. A well-composed drawing is inviting to the eye. Every space or shape represents something, and these shapes are called positive and negative space. The positive shapes are the objects in the landscape, the negative space being the spaces between them. Composition is how these two kinds of space are interwoven.

'How large do you make a tree? How much space do you devote to the sky? To the left, I have composed the same subject three times, giving attention to different aspects of the landscape. Through composition attention is given first to the most important features, and then to the areas of secondary interest. Remember, the eye must not be led out of the picture before it has been on a guided tour within it.

'As I draw, I try to take account of the following danger zones in the "picture space": Corners are natural arrows pointing out of the picture. Redirect the eye away from these natural exits. Edges are the frame. If you emphasize them too much then they draw attention to themselves and detract from the major areas of interest. Avoid putting shapes and details along edges. The centre is a fixed and automatic resting place for the eye which can be hypnotized into remaining there. Lead the eye beyond and around this area so that the picture may be seen as a whole.

'Notice the river scene recomposed without attention given to the danger zones! I list a few other dangers to consider: Don't cut your picture into equal proportions. Don't draw shapes which abut, as this flattens the picture. Don't repeat the same kind of shapes without variation of scale. Don't forget you need to emphasize the focal point, or area of dominant interest.

'To turn to the positive, creative aspects of composition: Contrasts of all kinds are important. If you wish to communicate largeness, then put something small near it. Contrast light with dark, thick with thin, etc. Balance implies distribution of tonal weight. Check your composition and ensure an harmonious whole. If attention is drawn to one side only, then the picture will be out of balance. Rhythm holds the picture together – like a tree by its branches. Shapes brought together create lines which run from one part of the drawing to another, creating rhythms. These can excite or soothe, but should not be so wild as to distract, nor so monotonous as to become boring.'

Corners, edges and the centre.

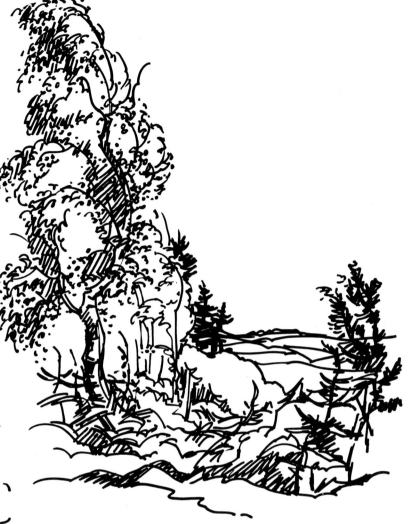

Rhythmic lines in felt-tipped pen vitalize an otherwise quite simple scene.

Drawings by Margaret Merritt.

An example of poor composition. The shapes are too regular, there are distractions at the corners, the horizon is central.

Composition

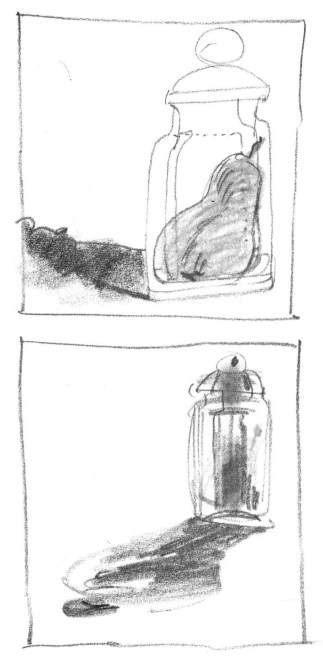

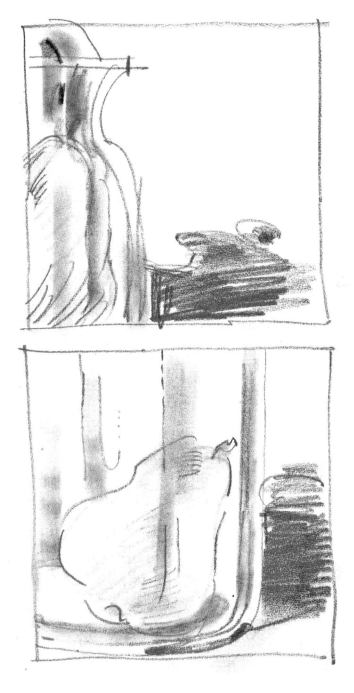

Four compositional notes for the finished drawing opposite.

Composing still life

George Cayford says, 'My composition sketches do not indicate how the finished drawing will look, yet they help in establishing the composition tonally. In them, I try to find out what it was about the subject which attracted me to it in the first place – what is my concept of "pear in glass jar". The reason, I found, was to portray the effect of how the glass, in its transparent and mechanical perfection, enhances the fleshiness of the pear which is trapped inside it.

'As you will see, I tried out many roughs for composition, materials and lighting effects in an effort to

realize the original concept. The roughs shown opposite were just a selection of the many I needed to do. These constitute a most important part of picture-making: however well drawn, the picture will fail to interest and satisfy unless the composition is exciting and enhances the original concept.

'I kept the compositional studies deliberately loose and sketchy, blocking in tones roughly as well as the linear pattern. In this way, I could see how my compositional sketch worked for me within the picture frame I had chosen. They were not completely accurate but provided me with enough information to compare and ultimately choose the final composition. In the bottom right-hand sketch opposite, I began to catch the relationship of pear to glass, although, for the final drawing I selected the top left-hand rough even though I felt that any of those depicted were "right" enough to be developed if I so chose. I chose the one I did because it allowed me to explore the qualities of both pear and jar thoroughly, at the same time as showing the relationship of the one shape trapped in the other.

'I wanted to give a crystalline, almost super-realist quality to the finished drawing. The paper I used was semi-smooth – a "Not" surface cartridge – for a rough-textured paper would have been too pronounced and not produced the smooth effect I wanted when drawing the jar. I drew the pear with a cross-hatch technique, using crayons and a 7B graphite pencil. I used a ruler as a mask to help give a sharp, clear edge to the tonal areas of the drawing of the glass jar. I worked the main components together, always trying to realize the original ideal I had in mind when I first started to study the subject: I stopped the moment I found I had achieved this, for an over-worked picture almost always lacks visual sparkle and interest.'

Drawings by George Cayford.

The finished drawing.

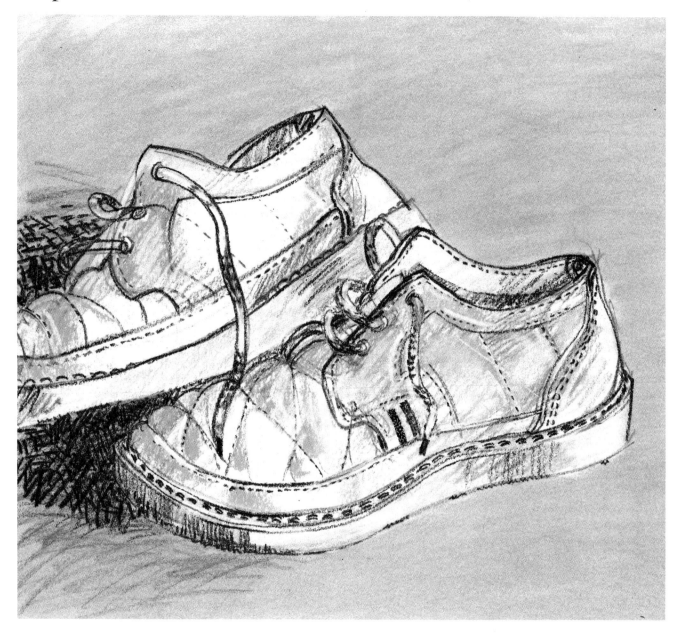

Jogging shoes , by George Cayford. In this composition, apart from the shoelace dangling vertically, almost all the lines converge towards the toe of the far shoe – and that the artist has deliberately cut out of the picture! Because you are sophisticated in looking at pictures you can recognize half or even a small piece of an object without seeing the rest – in fact the piece you are given heightens your intellectual interest in the picture so long as that part gives you sufficient clues to fill in the rest with your imagination. In this picture this reinforces the casual, imposed aspect of the jogging shoes – they look as though they have been chucked in a corner.

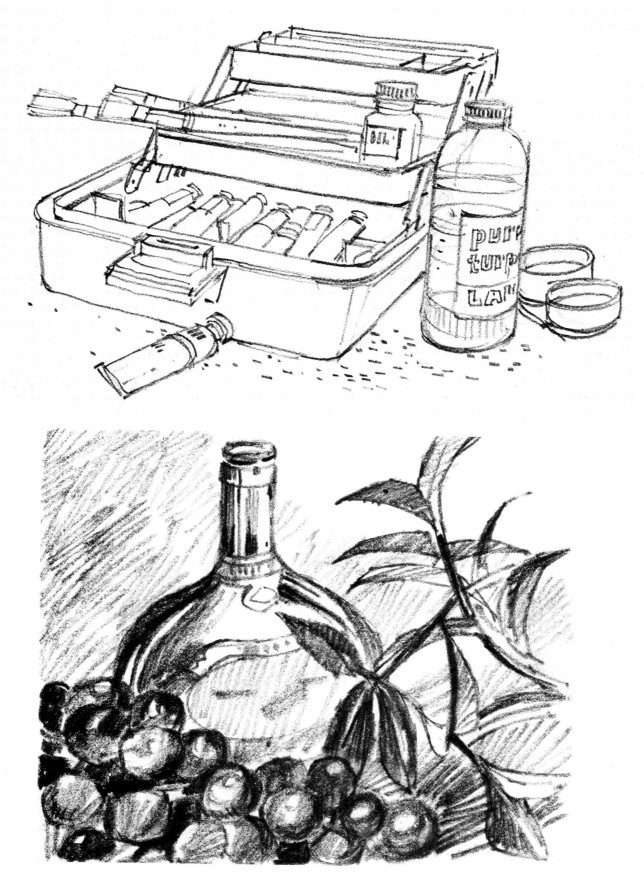

Two still-life studies by Norman Battershill.

Animals

Animals are endlessly fascinating. To draw them, some people can work from their own pets, others will observe wild birds, or farm animals, or park deer, or animals in zoos. But always there are two things to remember. As Sally Michel explains, 'Firstly, you are drawing a living being. It has a character and mind of its own; it is an individual, with its own likes and dislikes, its own personal characteristics of temperament and physique; and it is as different from other individuals of its kind as is one human being from another.

'Secondly, animals move. The sleeping household pet has the advantage of being less likely to vanish than a wild animal. If it wakes it can perhaps be bribed to stay with food or a saucer of milk, as garden birds can be lured with bird tables and strings of nuts. Soothing sounds and stroking can help to settle a nervous cat. But when you are drawing an animal, try not to catch its eye: it will either be embarrassed and worried by your fixed and contemplative gaze, and leave; or it will assume that you are inviting it on your lap where it will be too close for convenience.

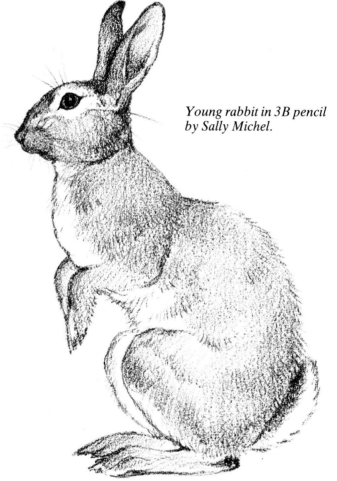

Young rabbit in 3B pencil by Sally Michel.

Studies of a sheep's head drawn in 2B pencil on grey sugar paper, by Clifford Bayly.

'Garden birds can be observed from behind a curtain. If you get them used to coming to the same spot, then you can keep paper and pencil handy, so that you need waste no time in finding your equipment, nor frighten them away by flapping the sketch pad in their view.

'When you work in zoos and parks, take advantage of other spectators feeding or talking to animals and birds. Time spent watching your animal is well spent, either before you begin or as you work. Observe how it moves, and what are the characteristic attitudes that it adopts in repose. Every dog or cat has its own favourite resting postures and personal habits.'

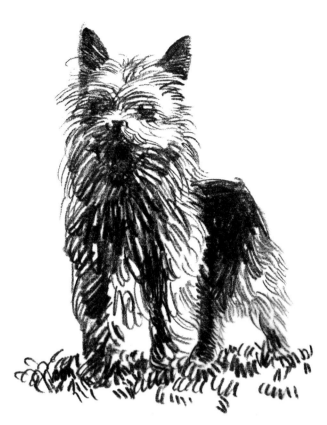

Gulls in flight, using a fine dip-pen and ink with touches of wash.

Horse studies in fine dip-pen and ink. Not only does each sketch indicate restlessness on the part of the subject: the whole page is alive with movement.

Graphite drawing of a terrier.

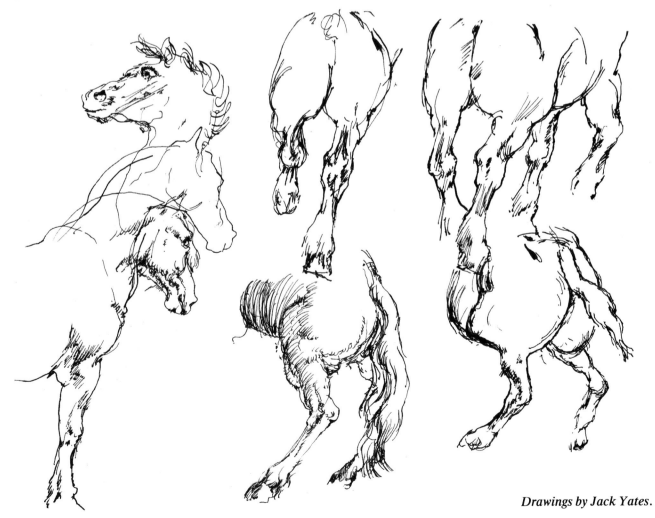

Drawings by Jack Yates.

Animals

Quick studies of horses in HB pencil.

Preparing to study your animal

If you have little experience of drawing animals, then do not take on too formidable a task to start with; try to start with a sleeping subject. If you have a pet of your own, a cat or a dog, then this should be easy enough; if not, then perhaps a friend can be persuaded to prevent their cat from going out of the house for a while in order for you to draw it. If this cannot be managed, then there are few dwelling places where birds cannot be seen. Failing that, parks often have a large bird population, and sometimes a stretch of water with the larger water-birds, which are generally very tame and accustomed to the presence of people. In parks, also, there are usually dogs to be seen, and in some cases, squirrels or even deer. However, these are not so likely to keep reasonably still as is a cat or dog in its own home.

It is a good idea to carry a small sketch-book, which will fit into a pocket or handbag, and a pencil so that you can take advantage of any opportunity to draw that may occur. When drawing animals you must always be prepared to leave a sketch when the subject moves and to start another; do not succumb to the temptation to continue the same one, as this leads to anomalies of perspective and anatomy. Numbers of separate incomplete drawings are, in fact, very useful; although each on its own is of limited scope they can in combination be used to build up a complete picture of the whole creature.

Animal anatomy

Sally Michel advises, 'It is helpful, when drawing an animal, to have some awareness of its anatomical structure, to supplement your observation. The structure of the vertebrate skeleton is not so very different from that of man; although the proportions are different, the bones of vertebrate animals, even of birds, are recognizable as the counterparts of those of man.

'Most museums have some mounted skeletons of familiar animals, and it is worth looking at these and drawing one or two. You can then look with more understanding at the living animal; if you are able to handle it, then you will discover more about the way it fits together. Drawing mounted stuffed specimens can also be useful, for the study of proportions and hair colour and growth, and will also help you to draw from live animals.'

Arctic fox (stuffed specimen in museum).

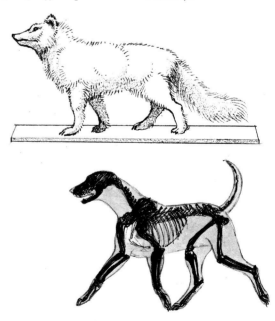

Skeleton drawing of a running dog.

72

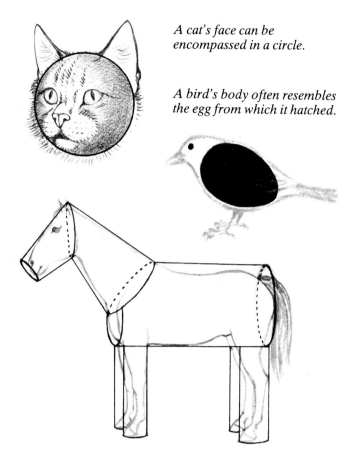

A cat's face can be encompassed in a circle.

A bird's body often resembles the egg from which it hatched.

'Blocks' superimposed on a horse drawing show the main forms.

Getting started

'Once you have chosen a model', continues Sally Michel, 'spend some time studying it. If you are indoors with an animal that does not know you, drawing some one else's pet for instance, then let it get used to your presence before you begin to examine it. Animals dislike being scrutinized, particularly by a stranger. Talk to its owner for a while, so that it may watch you unobserved, get used to you, and see that its owner accepts you. When it seems ready, make friendly sounds to it, and pat or stroke it if it will let you. It is of great help when drawing an animal to be able to feel it gently, but don't try this unless you are sure the animal is ready for such familiarity.

'When these overtures are completed, sit comfortably with your board and pencil, but not directly in its line of sight. (It is, of course, easiest to start with a sleeping animal.) Look at it, and decide what are the proportions of the main forms, and what their positions are in relation to you. The body first; look to see whether it is lying across your field of vision, or receding away from you, and if so, at what angle. Rough it in very lightly, then add the head and the limbs, using only the most generalized shapes; details can be added after the form and proportions are correctly worked out.

'Once the main structure is settled, more secondary forms can be added; the time spent on establishing the basic form correctly will ensure that anything added later in the way of details, patterns of hair growth and markings will be in their right places. You may leave out any details that seem unnecessary to the finished work; what is not permissible is to put in anything that is not there.'

Drawings by Sally Michel.

Try to see the main forms of your animal in order to establish proportion, after which add the features.

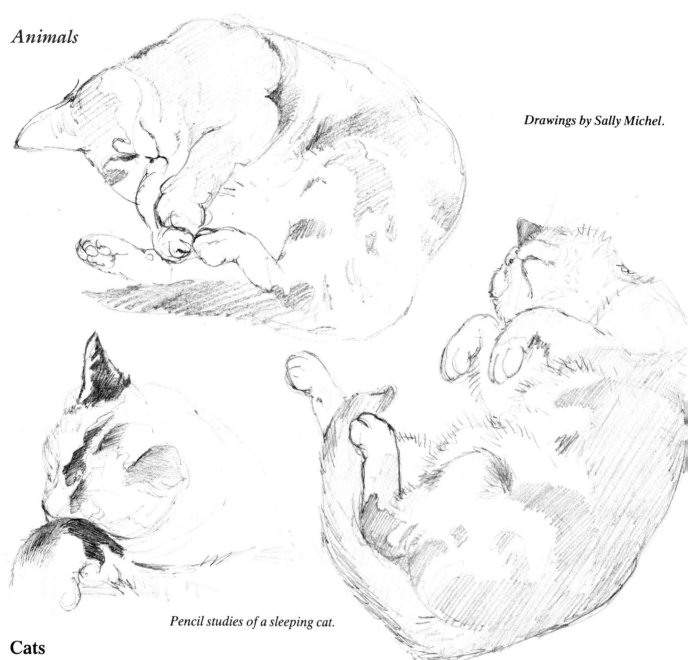

Drawings by Sally Michel.

Pencil studies of a sleeping cat.

Cats

On the subject of cats, Sally Michel says, 'The difficulties of capturing the actions of cats as they leap, run, climb, play and stalk are such as to bring the artist to the verge of despair. The movements are so swift and sudden that there is hardly time to see the essential elements of action, let alone draw them.'

Fortunately, however, animals sleep a lot, and cats in particular adopt many unconventional positions as they sleep, first on their side, curled up, but after a time stretching, rolling over and then settling down again. Sally Michel makes a great many pencil drawings in preparation for her paintings, some left unfinished as the cat moves, but all conveying the charm of a thoroughly relaxed animal.

When drawing a moving cat, her method is to reduce the whole problem to a kind of shorthand. She continues, 'When, for instance, I want to draw a margay mother and kitten flying around their cage chasing each other, I cover sheets of paper with curved lines which to me indicate the shapes assumed by their bodies and the position of legs, heads and tails. On their own these

would be of limited usefulness, but by using them in conjunction with the more complete drawings I make when they are reasonably still, I am able to build up a picture of them in action.

'I have to practise selecting the essence of the action and recording it quickly: the drawings are not impressive, but they are a kind of code, a reminder of what I saw for one second, and they serve to prompt my memory.

'There is an excellent and most useful technique taught in certain art schools which is particularly helpful to artists drawing moving subjects; that is, the practice of drawing continuously without taking your eyes off the model, having trained your hand to draw unwatched with reasonable accuracy. This is exactly what you need when drawing from the many excellent natural history programmes on television, which often only give very brief glimpses of what you can otherwise rarely, if ever, see – healthy wild animals in their natural habitat. The slow motion sequences sometimes included in these programmes are invaluable.'

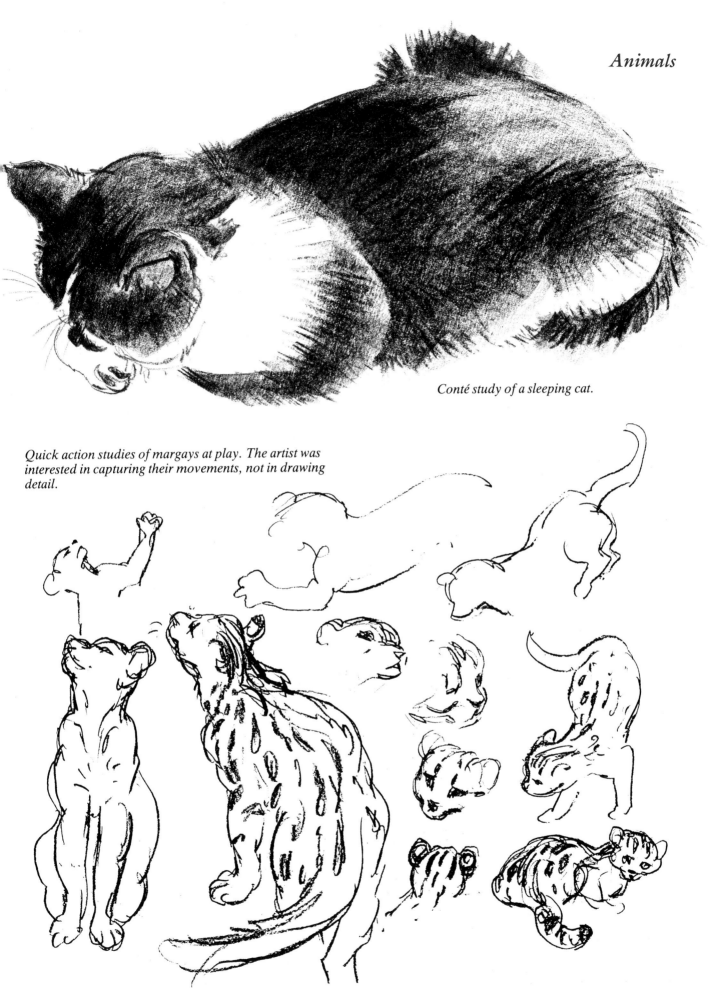

Conté study of a sleeping cat.

Quick action studies of margays at play. The artist was interested in capturing their movements, not in drawing detail.

The elkhound is the closest to the wolf-like animal from which all domestic dogs are most probably descended.

A little dog scratching. Its ear is drawn with an extra thick, soft pencil.

The greyhound is one of the oldest breeds, with long legs and long jaws.

The dachshund is the victim of breeding that has nearly got rid of its legs; this breed suffers greatly from slipped discs.

Dogs

Although the domestic dog is a single species, the range of dogs' sizes, shapes and coats is extraordinary. Also, dogs have a wide range of expression, in spite of their lack of facial mobility. Moods and feelings expressed on a human face by means of movements of lips, eyebrows, cheek and forehead muscles, are shown by animals in movements of the head, ears, tail, even the whole body. A cheerful dog expresses its mood with erect head and tail, and paws lifted high as it trots along; whereas a dog conscious of having done what it has been trained not to do expresses its contrition with equally telling body-language, grovelling with hanging head, rolling eyes, and tail between its legs.

The following drawings by Sally Michel illustrate some of these variations.

Drawings by Sally Michel.

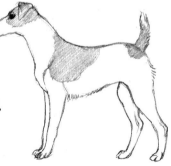

The King Charles spaniel has an abnormally short nose, and an abnormally long and wavy coat.

The fox terrier shows no extraordinary distortions. Although it was born with a normal tail, this was cut off.

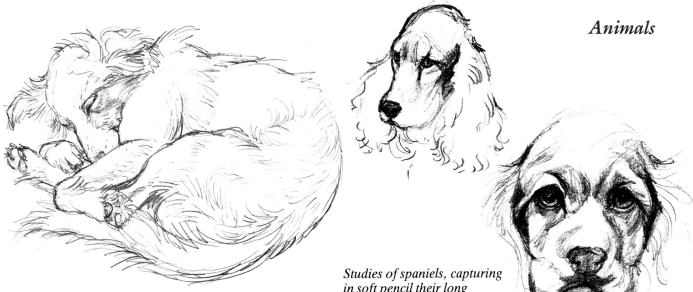

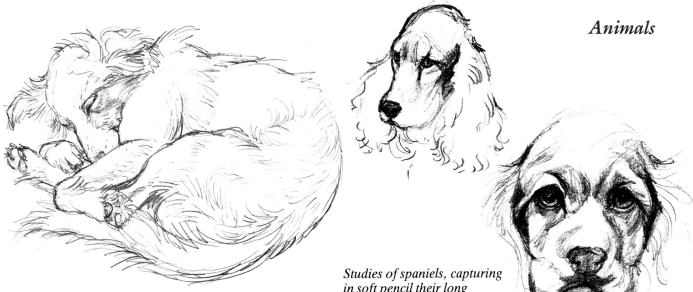

Sketches of farm animals by Sally Michel.

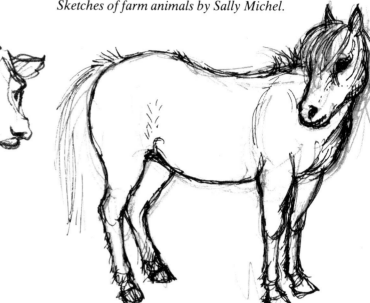

Working out-of-doors

Outside the home there are many and varied animals to be found both in town and country.

Working horses are rarer than they used to be, but a revival of interest in them has led to an increase in horse fairs which take place all over the world, where one may see Shires, Clydesdales, Suffolk Punches, all dressed up in ribbons and bells, groomed and polished to perfection. Sheep and cattle are to be seen in most rural localities – in spring, in Kent, sheep and lambs graze in orchards and churchyards as well as in the fields. Pigs are not so easily found out in the open, unfortunately; their coarse cheerful faces have considerable charm. Donkeys and goats nowadays are more commonly seen than for many years; herds of deer can be found in parks, and water-birds on rivers and ponds.

These can all be seen without going to zoos, where many more species are available, although their surroundings may leave something to be desired.

Sally Michel's equipment for working in either countryside, park or zoo is the same, for it needs to be in as light and compact a form as possible. She says, 'I usually take a small thin drawing-board (with bulldog clips) in a light portfolio containing plenty of paper; and a hold-all for pencils, crayons, pens, knife and eraser; and sometimes a small watercolour box, a few brushes, a screw-topped jar of water, and rag or a few sheets of paper towel. If I work in a sketch-book, then I usually remove the drawings as they are done and put them into the portfolio, as they often get rubbed and spoiled when left in the sketch-book. In any case, all my drawings are filed into folders when I get home, according to species and breed.

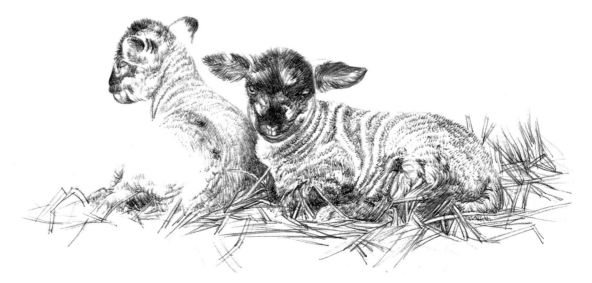

Lambs in ball-point pen by Sylvia Frattini.

'I rarely take either a sketching easel or a folding stool for this kind of work, but reserve them for the occasions when I am working on landscapes. This is because you are bound to have to move about when drawing animals; it is essential to be free to follow your subject in order to see it from a consistent viewpoint.

'Working in the open gives opportunities for drawing animals at a distance; this forces you to sum up the character of the whole animal and its movements on a small scale yet without details.'

Wild birds in great variety can be seen in gardens and parks, while any stretch of water will have a considerable and varied population.

To study them a camera is useful – draw what you can, but take photographs as well if you are able. Other people's photographs can also be of assistance, but only for the purpose of supplying additional information to supplement that contained in your own drawings, and not on any account for copying.

Drawings by Sally Michel.

Conté sketch of a strutting bantam cockerel.

Study of a perching bird.

If a trip to a zoo is a rare event for you, then cover as much ground as you can comfortably manage; if you are likely to return before too long, then choose a few interesting subjects, and do many drawings of each. You can then use these to prepare the foundation of a picture. You will probably have a number of incomplete animals and details of heads, feet, ears, and markings, and a few slight sketches of the complete animal.

One of these can be chosen as the subject of the picture, and drawn, in the size and position required, lightly, on whatever paper, board or canvas you have chosen.

Siberian tiger drawn with a fountain pen and black ink.

Landscape

Ray Campbell Smith says, 'A student on one of my courses once spent several hours looking for a subject to draw, despite the fact that we were in a delightful farming area, with a wealth of material from which to choose. The problem was that she had a preconceived and rigid idea of what she wanted to draw, and so her mind was closed to everything else.

'The artist should cultivate an open mind, receptive at all times to external impressions and stimuli. With such an attitude you do not have to look very far, for subjects will quickly present themselves and evoke a response. The chosen subject need not be a conventionally attractive landscape and could equally well be a group of humble farm implements by a barn door, or any one of a thousand other possibilities. The important thing is that something about the subject should strike a chord and challenge you to say something fresh and exciting about it. Only thus will you be able to convey to others something more than a mere pictorial likeness.

'One of the problems that causes inexperienced artists constant difficulty is that of separating a promising subject from a mass of surrounding, irrelevant detail. A grand panorama that would daunt a Constable seems to have an irresistible appeal, when a small section of it would make a far more satisfactory subject. This is

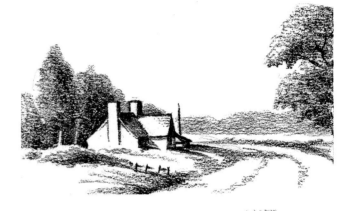

Preliminary sketches.

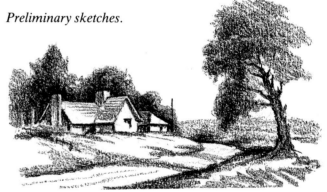

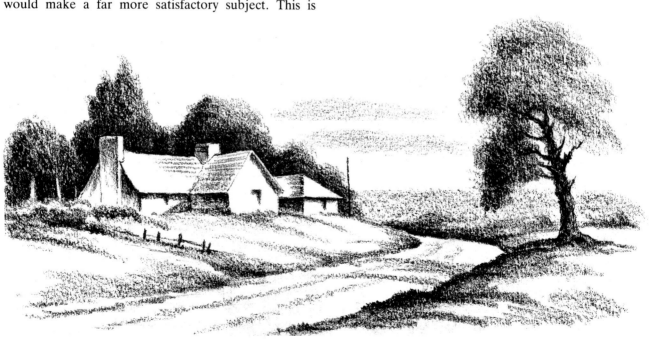

Finished drawing.

Drawings by Ray Campbell Smith.

80

Here, the artist has chosen Conté crayon to show a picture of a rocky coastline on the Mediterranean. By breaking the stick into a short length, she blocks in the main tonal values, using the side of the Conté stick, and then adds details and contours afterwards.

**Drawings by Margaret Merritt
using different media to depict landscape.**

where a home-made viewfinder is so helpful (see page 18). By holding it up to an extensive vista, you can readily isolate more manageable sections of it. The area within the aperture can be increased or diminished by moving the viewfinder towards or away from the eye.

'All sorts of considerations enter into your choice of subject. Pleasing composition comes high on the list and interplay of light and shade runs a close second. Are there good areas of light to be set against strong dark areas to provide effective and sometimes dramatic contrast?

'Most landscape subjects can be tackled from a number of different viewpoints, and, it is a good plan to make several quick sketches from various vantage points. This will help you explore the subject in depth and a comparison of the sketches will probably help you decide which yields the most pleasing composition. The two small sketches opposite, are quick Conté impressions of a simple landscape subject from different viewpoints and the one that appealed to me formed the basis of the finished larger drawing.

'Try to keep your sketches and drawings free and loose. There is nothing more inhibiting than a tight, exact style with not a line out of place. Your first, exploratory strokes should be light and tentative, never hard and uncompromising. As your drawing develops, those that are significant can be strengthened and the remainder ignored.'

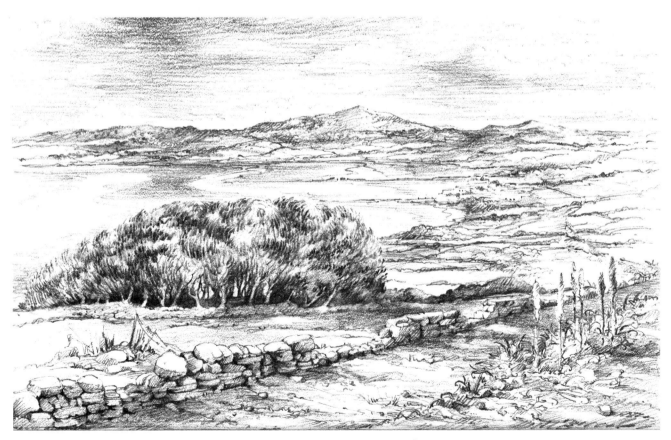

Detailed study of a Minorcan landscape in 6B pencil. Notice the variety of tone and line.

Skies

Drawings by Margaret Merritt.

How you are affected by the weather! And how it affects all you perceive. A cloudless, azure sky with the sun burning everything below it may be pleasant for the sunbather, but it is relatively uninteresting for the draughtsman. Yet as soon as clouds appear another dimension seems to enliven the landscape, throwing light and shade across it, highlighting one aspect one moment, casting it into shadow the next. John Constable wrote ' . . . every gleam of sunlight is blighted to me in the art at least. Can it therefore be wondered that I paint continual storms?'

On these two pages Margaret Merritt offers sky sketches and drawings, some with attendant landscapes, others which are studies simply of the shapes and masses that form clouds. Study the sky as a subject in itself, as Constable did: or go further (as he also did) to relate the interplay of sky and land, sunshine through cloud, shadow of cloud upon field, woodland and hedgerow. So avoid the sun at its zenith – wait until its angle at morning or later afternoon is raking across nature: the clouds will then be thrown into relief and shadows dramatize the objects that rear up vertically from the landscape.

Margaret Merritt's sketches are done spontaneously and quickly in a variety of media. 'One of the problems,' she says, 'is that the blue sky is often darker than the clouds themselves. A wash or tonal block will establish the colour of the cloud at its outer edge very effectively.'

An expressive study in evening light of a rocky landscape with an old fort. The artist has chosen grey Ingres paper, first drawing with 6B pencil, then with flexible pen and black ink, finally laying on thin washes of white paint and picking out the highlights with thicker white.

On the opposite page, and on this page, left and below, are various studies of cloud formations in light pencil and watercolour, fine water-soluble felt-tipped pen afterwards loosened with clear water to produce tone, and Conté.

Drawing by Leslie Worth.

Water

By comparison with the sea, the land is relatively undisturbed by the wind. But a zephyr can disturb the sea's oily smoothness – stronger than that, it can raise wavelets, or immense breakers. Sun and moon also play their part in the creation of tides: no wonder the places where sea meets land exert such a fascination upon artists!

Take your sketch-book when you visit the seaside. Subjects abound there. Our artists have already shown how sky and earth interact to provide endless variety. This is just as true with seascapes. In the tonal sketch above, in pen and wash by Leslie Worth, a simple subject such as a breaking wave provides a dramatic drawing. But you have to watch hundreds of waves before you can capture such a subject; it is not just a particular wave but a synthesis. Sometimes you have to observe a seemingly endless repetition of events – in order to analyse such a picture before arriving at the moment to capture it. Make quick notes until you find that moment which satisfies you.

Rocks, sand, cliffs, houses, piers, boats – things man-made or natural – all have their place in seascape. The thumb-nail sketches in Conté at the bottom of this page could be made into very detailed studies. Make plenty of such notes before settling down to draw your picture.

Sketches by Norman Battershill.

Rivers, streams, lakes, and ponds occur very frequently in the landscape and, indeed, contribute greatly to its variety and beauty. They are of particular interest to the artist, for they provide him with that which he is constantly seeking – contrast. Contrast of form occurs when a flat sheet of water acts as a foil to the vertical shapes of the fringing trees; contrast of tone results from the counterchange between a shining expanse of water and the darker terrain beside it. Ray Campbell Smith states, 'Water gives the landscape artist an extra dimension in his work. Rivers and streams, correctly observed, can carry the eye deep into the heart of the drawing and this is an extra bonus. They should never be allowed to carry the eye straight off the paper. In the pencil sketch, right, the shining water of the river disappears round a bend and is not permitted to continue, uninterrupted, to the edge of the drawing. The perspective has been carefully handled so that the water lies flat and does not appear to be flowing uphill, as is sometimes the case with the work of beginners! When a local breeze ruffles the surface of the water, the sky above is reflected rather than the landscape beyond and this gives rise to a stretch of pale toned water. This can sometimes be put to useful effect by separating the scene beyond the water from its reflection.'

Very calm, unruffled water acts as a mirror and so produces a mirror image of the scene above. This can look attractive in photographs but is best avoided by the artist in the majority of cases. Unless the scene is a particularly simple and uncluttered one, an inverted replica below usually leads to over-elaboration and confusion. Except on abnormally still days, there is usually a slight ruffling of the water's surface and this causes a softening and a diffusion of the reflection. In this way the reflection complements the scene above instead of competing with it.

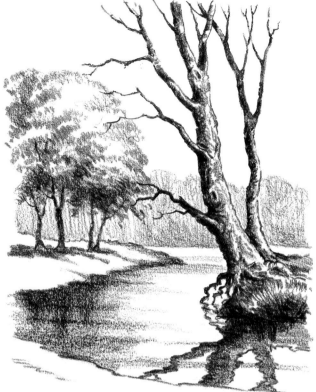

Dead tree by a river by Ray Campbell Smith.

Fibre-tipped pen and wash drawing by Peter Caldwell.

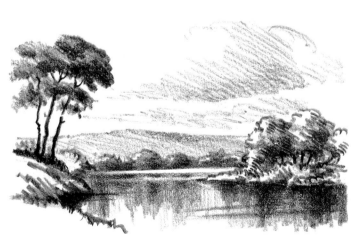

Mountain lake by Ray Campbell Smith.

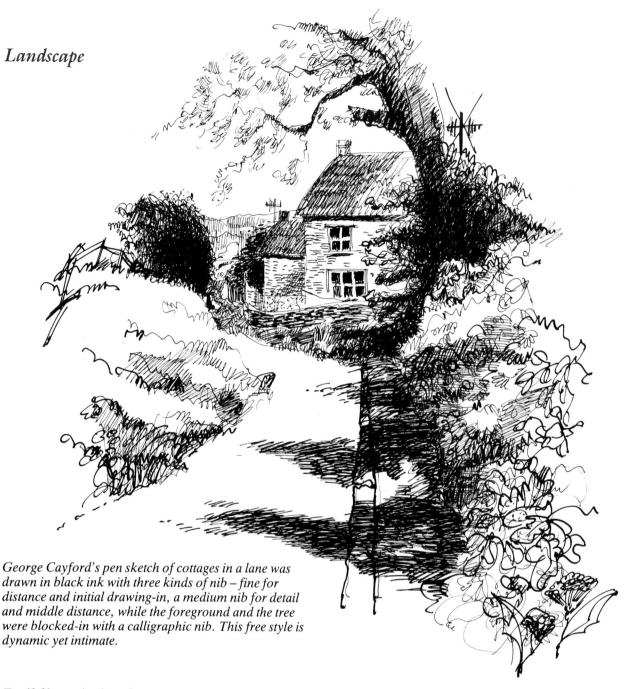

*George Cayford's pen sketch of cottages in a lane was
drawn in black ink with three kinds of nib – fine for
distance and initial drawing-in, a medium nib for detail
and middle distance, while the foreground and the tree
were blocked-in with a calligraphic nib. This free style is
dynamic yet intimate.*

Buildings in landscape

It is hard to find, when we are drawing outdoors, a
landscape that is devoid of any form of human artefact,
be it houses, bridges, or even telegraph-poles or pylons.
One of the advantages an artist has over the camera is
the ability to select; but buildings have their place in a
landscape drawing – their hard angles and materials
provide different textures in contrast to the organic
material that surrounds them. A building can be (and
often is) a focal point in landscape pictures: a church
spire or long low barn, even a town or village in the
distance – all will add to the interest of a drawing. Study
the land and look at its form and texture. Learn to do
this by spending as much time as you can drawing
outside in all weathers. Such practice improves style,
technique and accuracy; but it is your own interpretation
that will make the difference between drawing a
landscape and merely producing a photographic like-
ness.

'Draw lightly,' Norman Battershill advises, 'and resist
the temptation to erase mistakes. If your drawing goes
drastically wrong, then start again. Before you throw
away a bad drawing, study it to analyse where you went
wrong: we all learn as much from our mistakes as from
our successes.'

Ray Campbell Smith says, 'In the minds of many
people the word "landscape" is virtually synonymous
with "countryside" and it would not occur to them that
built-up and industrial areas have just as much claim to
that title. But artists should learn to respond to the rich
and often dramatic possibilities that industry frequently
has to offer. I have heard people say that they are not
interested in drawing ugliness for its own sake and that
there is already quite enough squalor in the world
without adding to it. This attitude, though understand-
able, misinterprets the nature of art. Drawings are, after
all, just a series of related marks, and whatever their
source of inspiration, they can be harmonious, well
composed and pleasing.

'Industrial subjects can be strongly atmospheric and can fire the receptive imagination. On the debit side, they frequently contain a bewildering amount of detail, but if you concentrate on conveying atmosphere and feeling, and greatly simplify the detail, the rewards can be great. One way of simplifying the subject-matter is to select drawing implements that will not allow you to add fiddly detail. There are several that fit the bill, including charcoal and marker pens.

'The sketch below is of a river running through an area of heavy industry. For this, I used thick black and grey marker pens, boldly and directly. The distance was put in with the grey to form a pale silhouette, while for the nearer features I used black for the shadowed areas, leaving the white paper to represent those catching the light. I used the grey marker pen here and there to tone down some of the white areas and so unify, to some extent, foreground and background. I used a fine felt-tipped pen to add just a little detail but did not attempt to tidy up the rough lines made by the thick, black marker pen. Finally, I put in the cloudy sky with charcoal, which I then rubbed gently with a cloth to obtain the soft effect I wanted. Just a quick impression, but with something to say about its subject.

'The mining village was sketched in charcoal and the finer detail put in with a well-sharpened Conté. I did a little gentle rubbing of the charcoal to soften the sky and the far hillside, but the boldness of the charcoal and the roughness of the paper surface combined to suggest the ruggedness of the foreground. The stream and the footpath both lead the eye into the drawing. The dark mass of rocky hillside on the left serves to balance the miners' cottages on the right and tonal contrast has been emphasized wherever possible. This quick and bold style of drawing relies heavily for its success upon counter-change'.

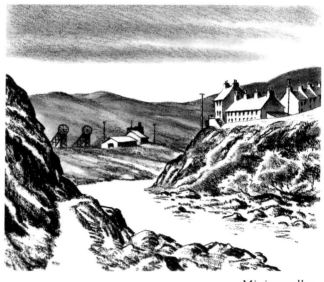

Mining valley.

Drawings by Ray Campbell Smith.

Industrial river.

Landscape

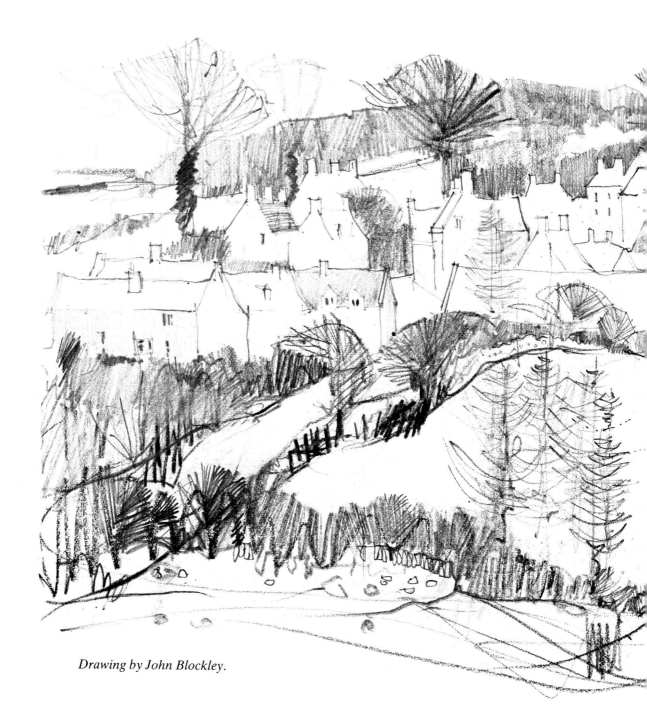

Drawing by John Blockley.

John Blockley's drawing of Cutsdean, a Cotswold village, in the depth of winter brings together in one study many of the points that have been illustrated earlier. Using soft pencil for the composition, he has also employed a graphite stick to add tone and emphasis where necessary. Notice how the whole picture is made up of distinct lines and marks – scribbles, dynamic and formal lines, and tones, are seemingly put down instinctively, yet each has its place in the composition.

The composition is based on a lozenge, the four sides of which run from the bottom left-hand corner to the tree, top centre, then down to the base of the church and

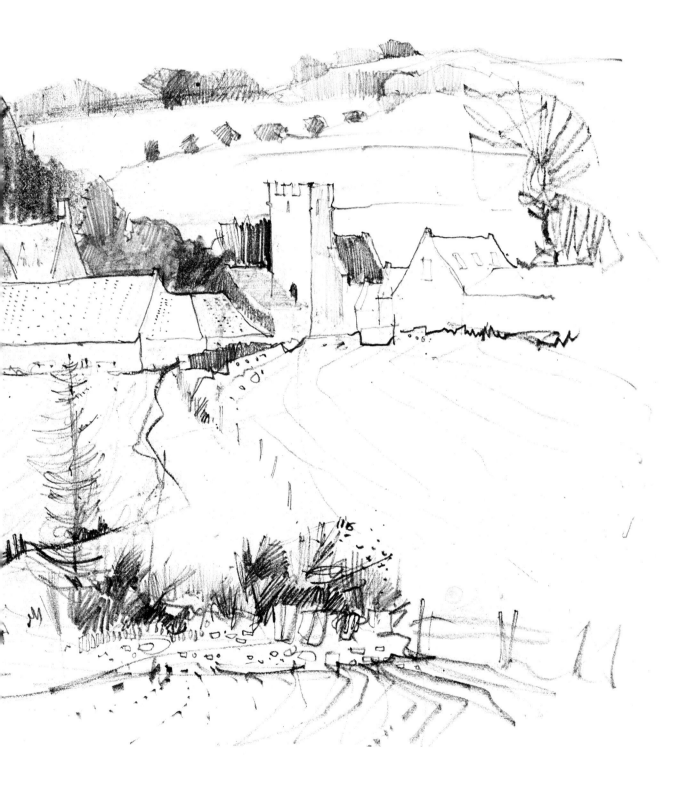

from there to the gate (bottom centre) and to the foreground. (Half-close your eyes and you will see the lozenge quite distinctly.) Your interest travels through the drawing, moving from line to blocks of tone, dark accents to light. Blockley uses the graphite stick on its side, producing varied lines and rhythms, at times hard and spiky, at others soft, in order to block in tone.

Other compositional lines and marks cross or radiate from the lozenge, the total effect being stark and wintry. Try to emulate some of the marks and lines he uses in your own compositions as an interweaving of continuums and punctuations.

Trees, plants and flowers

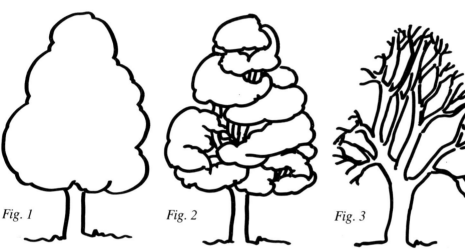

Fig. 1 Fig. 2 Fig. 3 Fig. 4

Trees are an essential component of most landscapes and, as Margaret Merritt says, 'are worthy of special study. If you wish to give them identity within a landscape, then you must study their structure carefully.'

She explains, 'My starting point when drawing trees is to simplify. I reduce their complexity to the most simple forms in the following sequence of illustrations. I often make these diagrammatic notes before starting an elaborate drawing which is built-up on similar simplified beginnings.

Fig. 1. I draw an outline of the tree's overall shape.

Fig. 2. I now draw the way the foliage is massed on branches which makes it look like a jigsaw puzzle.

Fig. 3. Now I draw the structure of the trunk and branches. These studies are best made in winter as preparation for summer painting. However, a study of an individual twig will give you the structure of the tree in miniature.

Fig. 4. The last study is a drawing of the overall texture. The rhythm of the foliage helps to illustrate its identity. Having made these drawings, I begin to understand the structure of the tree.'

Geometric forms

'A diagrammatic drawing of a tree looks flat,' continues Merritt, 'like a paper cut-out. You need to develop, therefore, an understanding of the nature of its volume and learn to show its three-dimensional qualities.

Fig. 5. To understand the volume, I first relate the tree to a basic geometric solid – the cone, cylinder or sphere. In the most simple terms, you can say that the trunk is always a cylinder. The mass of the tree is either a cone, or sphere, or a further cylinder.

Fig. 6. If you study the light effects on these geometric forms, then you get some idea of how light, from one source, falls on a tree.

Fig. 7. Light from one source envelops the tree. It bounces back from the space around and illuminates the far edge of the self-shadow.

'If the source of light in the landscape is not obvious enough, then exaggerate it and its effects.

'Once you understand that using a single light source helps you make a tree look round, you must then consider the inclusion of leaves, branches and other characteristics which give the tree its identity.'

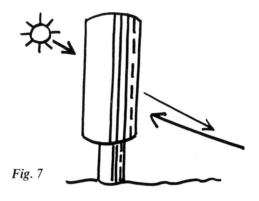

Fig. 5

Fig. 6

Fig. 7

Separating main forms

Merritt advises, 'The following studies should be drawn in morning or evening light when the cast shadows over the surface of the foliage throw the main forms into relief.

Fig. 8. Draw the light on the tree only, in white crayon on black paper.

Fig. 9. Draw the shadows only, using dark chalk on white paper.

Fig. 10. Using a medium-toned paper, draw both light and shadow in black and white.

'These studies will give you an understanding of the distribution of light on the mass of the tree. Keep in mind the following points: in highlight areas, detail is diminished; in deepest shadow areas, detail is diminished; it is mainly in the middle-tone areas, where there are cast shadows, that most detail of leaves and foliage is seen.'

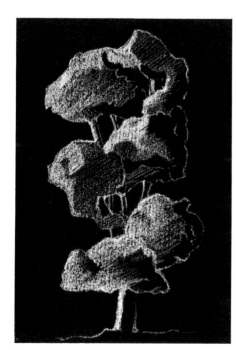

Fig. 8

Fig. 9

Fig. 10

Drawings by Margaret Merritt.

Trees, plants and flowers

Spruce in 2B Conté pencil.

Oak tree with foliage in fibre-tipped pen and pencil.

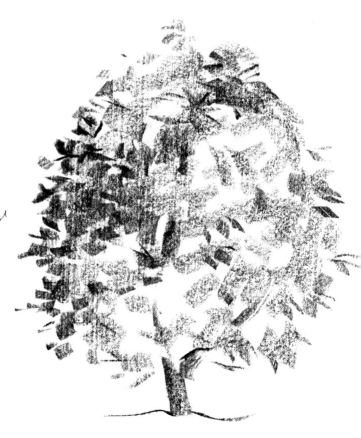

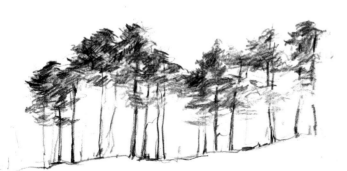

Scots pine trees in 2B pencil.

This Conté drawing, although elementary, has structure and mass, and the basic forms are indicated by tonal contrasts of light and shade.

A stylized drawing of an oak tree in felt-tipped pen and soft
pencil illustrates the importance of observing negative and
positive space. Through shading in pencil the spaces seen
through branches and leaves, the anatomy and bulk of the
tree are shown, and lend it conviction and solidity.

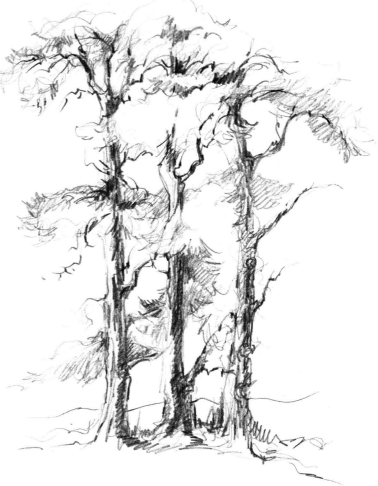

Three Scots firs in 6B pencil. Notice how important are
the negative spaces between trees and branches.

Drawings by Margaret Merritt.

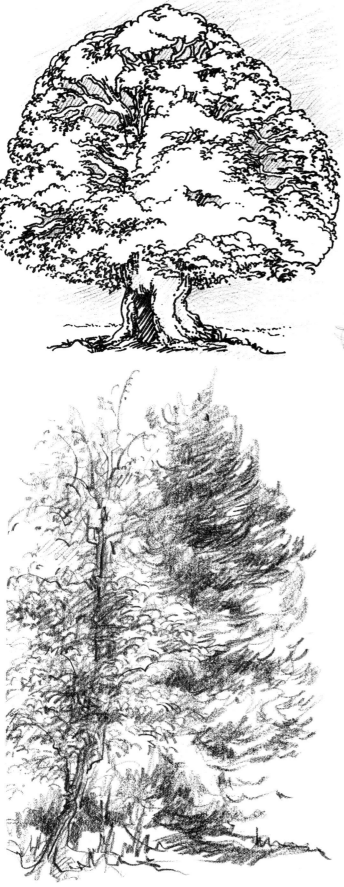

Contrasts in texture. A silver birch stands in front of a
sitka spruce (black crayon). The features and quality of
the former demand different kinds of marks from the
latter.

Trees, plants and flowers

Shrubs and bushes

When shrubs and bushes are seen individually, in isolation, differences in size and scale are not apparent.

Often, it is better to see shrubs and bushes together, in groups as found in gardens – shape against shape, texture against texture, size against size. Shrubs are often soft-edged, but should be seen at first as solid, hard-edged shapes, either light against dark or dark against light. Look for different contrasts before you start drawing.

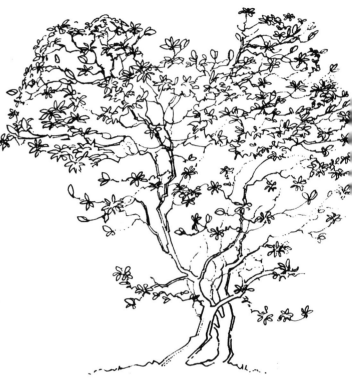

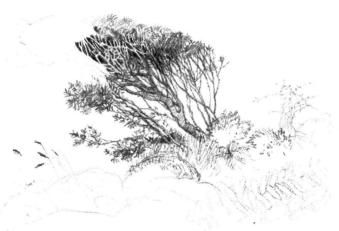

Magnolis stellata *in bloom, seen in isolation. Technical pen drawing by Margaret Merritt.*

Clifford Bayly shows dynamic use of tone in an unfinished drawing of a wind-blown gorse. See how the branches and twigs are composed: when silhouetted against the sky they are drawn in with dark pencil; when the mass of the bush is black he leaves the branches as white by blocking in around them.

The first stage in drawing a group of shrubs. Here, Margaret Merritt has chosen to indicate the main darks to help her define the edges separating each shrub. Carbon pencil.

94

Twigs, leaves and fruit

If you want to understand yet more about trees and bushes, then take a close look at their twigs, foliage and, during summer and autumn, their fruit.

Some twigs are long and graceful; others twist and turn, yet others are like arthritic fingers. Leaves come in all shapes and sizes, and are arranged in groups, pairs or singly upon the twig. They are shiny, rough, furry. By the same token the variety of fruits is endless.

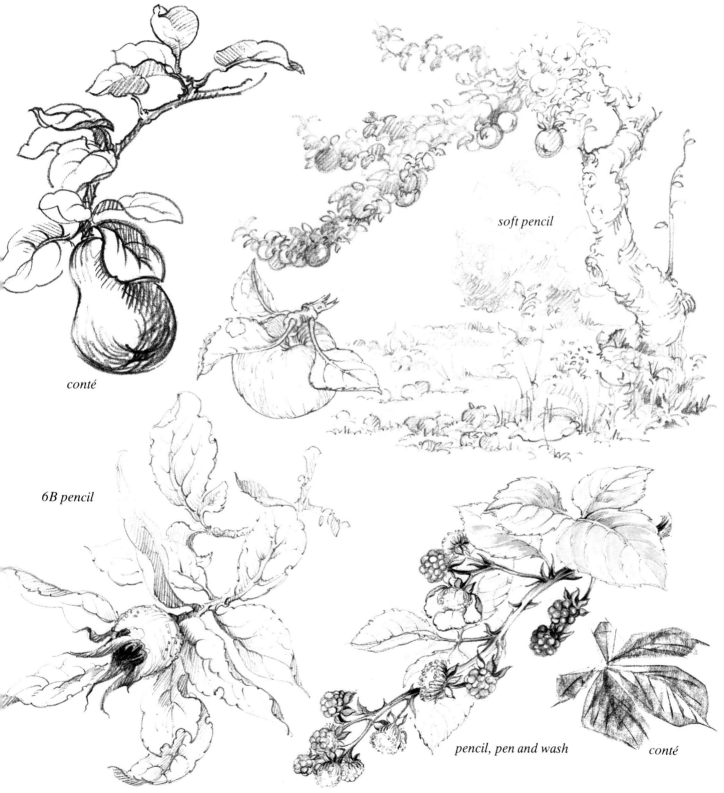

conté

soft pencil

6B pencil

pencil, pen and wash

conté

Drawings by Margaret Merritt.

Trees, plants and flowers

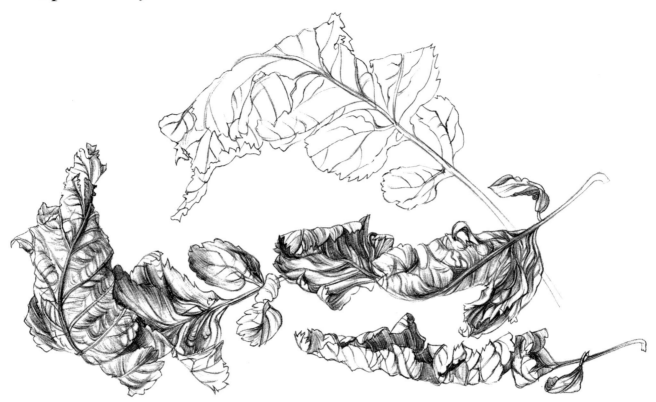

Autumn leaves in ball-point pen.

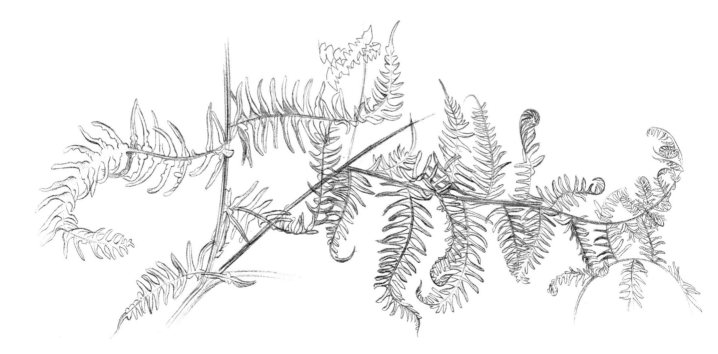

Withered fern in 2H pencil. Even in winter, leaves can provide an attractive subject for the artist.

Drawings by Sylvia Frattini.

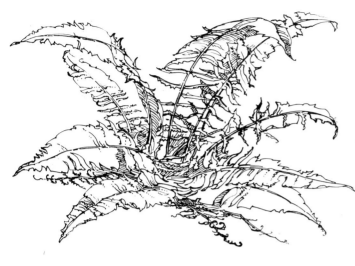

Lady fern drawn with indian ink and a dip-pen. This is the most common and frequently seen of the ferns, with a beautiful, radiating form.

Tropical plants drawn with compressed charcoal pencil. These plants offer exciting subjects, as they grow in prolific confusion with intertwining shapes and lush foliage. Determine beforehand the lights and darks, the positive and negative shapes, so that your drawing is not confused.

Drawings by Margaret Merritt.

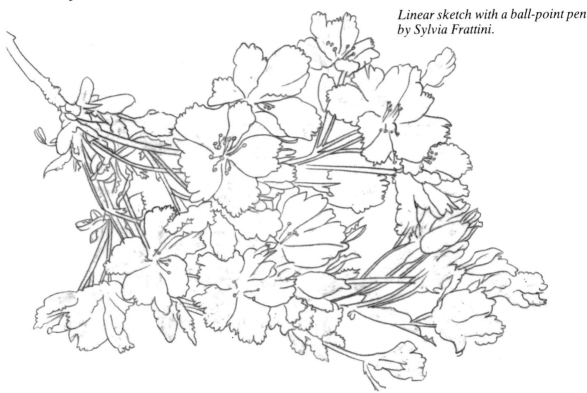

*Linear sketch with a ball-point pen
by Sylvia Frattini.*

Flowers

There is nothing more beautiful than the sight of a field
of poppies glowing in the sun, or meadows and gardens
full of brightly coloured flowers, and as a subject they
offer a rich source of inspiration to the artist. However,
before you start it is important to observe, study, and
practise drawing them.

Sylvia Frattini advises, 'Practise drawing flower heads
or blossom in varying positions initially to the same size
and proportion of the plant. If this proves too difficult,
then enlarge the scale of your drawing. Study the flowers
closely and carefully and pay particular attention to the
inside of the flower. Stamens form an interesting pattern
which makes a delightful contrast to petals. Study how
flowers and leaves are attached to the main stem.

Extend your drawing further by adding flowers;
alternatively, try drawing only the main outline of the
plant. Even a simple linear sketch made with ball-point
pen can be attractive.'

If you have difficulty in analysing the shapes of
flowers, then look for the underlying geometric forms.
Think of the daisy family as being composed of discs and
flattened spheres, daffodil trumpets as cones, and
bell-shaped flowers as a combination of spheres and
cones. Try a series of studies using different media to
portray the same subject, until you feel you have
captured your interpretation. And if you are at all
daunted, what better advice than Norman Battershill's:
'Why not begin with a single rose in a glass of water?'

Daffodils by Rosanne Sanders.

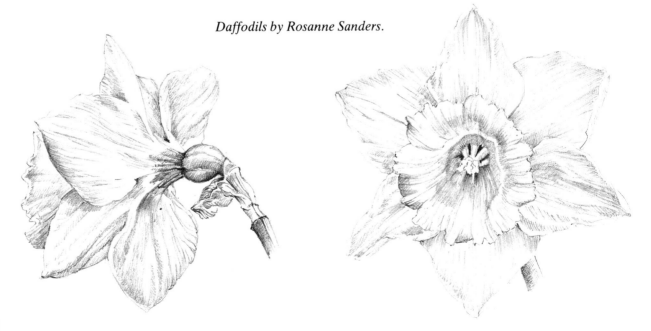

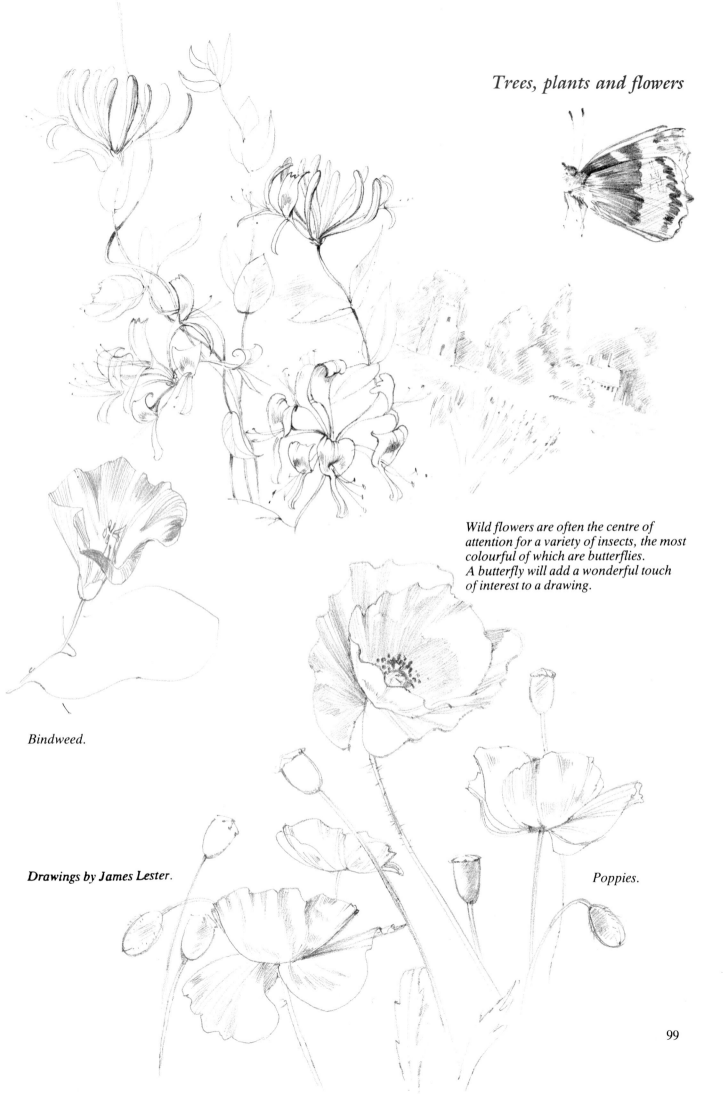

*Wild flowers are often the centre of
attention for a variety of insects, the most
colourful of which are butterflies.
A butterfly will add a wonderful touch
of interest to a drawing.*

Bindweed.

Drawings by James Lester.

Poppies.

Buildings and towns

Drawing buildings and towns is, generally speaking, more exacting than other forms of outdoor drawing. However, providing you can appreciate the necessity of working in a more deliberate and systematic manner, in the early stages you should not find the subject-matter unduly difficult.

Buildings, most of which have hard clean lines, can be daunting for the beginner who finds drawing freehand straight lines difficult. But, few buildings in fact contain absolutely straight lines as drawn with a ruler, for weather, age, and damage all take toll on their fabric. Again, the lines of most buildings are broken by protuberances, while plants, trees, lampposts and other objects interrupt and soften them.

When you are drawing buildings, remember to keep a light touch to your work from the beginning and to use a searching, broken line. Too much attention to detail sometimes leads to a tight, rather too mechanical look to the finished work.

Try to spend most of your time working on location. Get used to the bustle of the roads and streets, and to making quick notes from a convenient viewpoint. Never mind the curious onlooker; you can always put him in your picture when he walks away!

By using negative space (sheets on a clothes line) the artist creates a townscape by drawing the background in dark tones of soft carbon pencil on watercolour paper.

Chimney stacks drawn in HB pencil on cartridge paper. The purely linear aspect creates a keenly observed study – any further detail or added tone would destroy the elegance.

In this drawing, the textural quality dominates. Brick, stone, wood, and tiles, are all given their full value by careful use of tones.

Besides the buildings themselves, some of the most entertaining and rewarding objects to draw in streets and towns are items of what are called 'street furniture'. These include pillar boxes, street lamps, poster hoardings, notices and road signs, seats, tubs of plants, etc. Although the older, sometimes more ornate objects found in streets are more popular as subjects than their clean-lined modern counterparts, the latter have good simple shapes to 'punctuate' the busy street.

Also, try drawing from your own home – the windows, garden, yard or balcony can all be of interest. What to some onlookers may seem to be an 'unattractive' view of backs of other buildings or old sheds can make a most pleasant picture. Even washing on a line has its own quality. Perhaps the shapes between sheets hanging out to dry may be more rich than the sheets, as Clifford Bayly illustrates in the drawing opposite.

Windows' relationships to the surroundings – either reflecting sky or other windows or buildings, or open revealing deep dark interiors, people and objects – present the artist with first-class subjects.

When drawing from a balcony or high window the problems of perspective become more evident, but do not be too anxious for absolute accuracy. Try to find the characterful aspects of your subject, such as odd angles on walls, irregular brickwork, dipping roof ridges, crooked chimneys and rich textures.

A great advantage of drawing from your home is that of choosing your weather and lighting conditions. Wet surfaces can be most rewarding to draw and reflections can enrich quite a plain and uninteresting building.

Rooftops drawn in pencil on tinted paper.

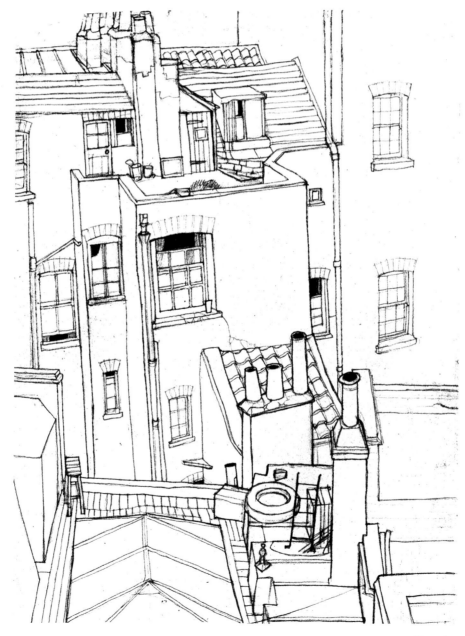

Drawings by Clifford Bayly.

Buildings and towns

Strong shadows can also add interest and character, particularly in early morning or afternoon. Peter Caldwell says, 'Twilight is a good time to work, although you have to be quick to capture the quality of that half-hour or so. I would recommend you make a series of visual notes – little tonal sketches of roof silhouettes, lighted windows, street lamps, shadow etc., possibly on several separate occasions, and build them into a more "finished" piece of work later. By this means you can capture more than would be possible in one evening, and exercise further your abilities in selectivity – reorganizing your drawing by keeping only the most characteristic elements and placing them in relation to each other to gain maximum effect with the minimum of means.

'Try making several drawings of the same subject under different lighting conditions. Monet did just this in his paintings of the front of Rouen Cathedral.

'Many artists tend to look at their chosen subject so full of admiration for it, and with such eagerness to put it down on paper, that they tend to overlook the shadows which sculpture the scene – shadows which form most of its appeal in the first place. On many occasions, I have been tempted to relegate the subject before me to secondary importance, and just record the wonderful shapes and patterns of the shadows.'

Drawing by Peter Caldwell.

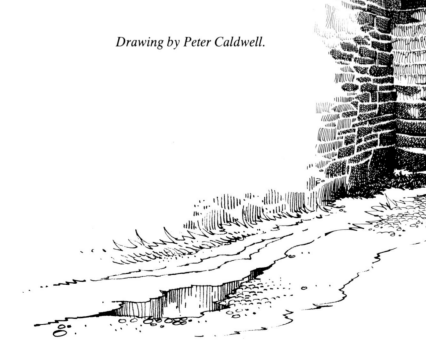

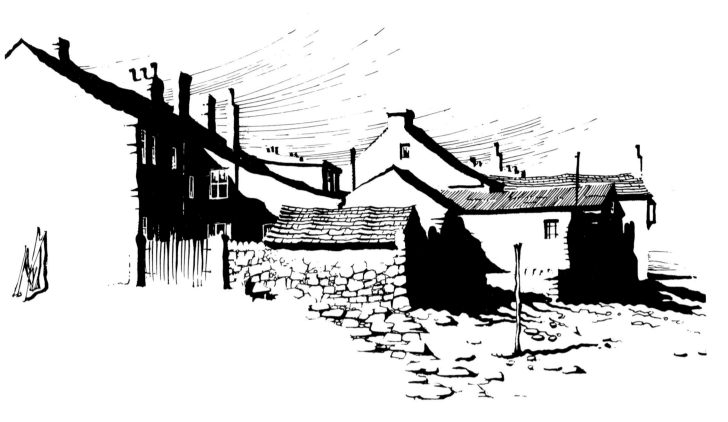

*Group of cottages in pen and ink, by Peter Caldwell. Minimizing detail, by
drawing the shadows only, gives the picture a dramatic feel.*

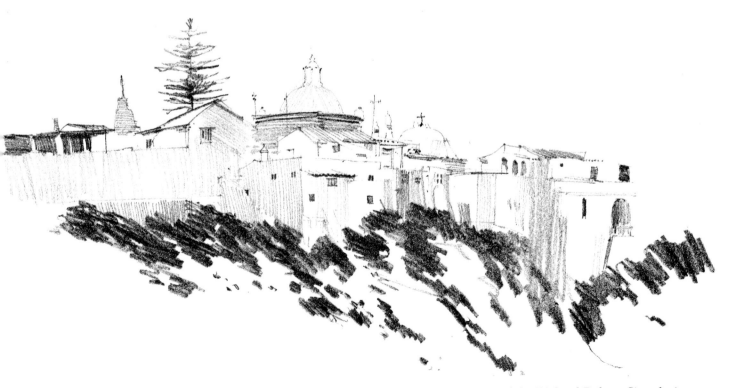

*Drawing of a Portuguese town in pencil, by Richard Bolton. Since he is
left-handed, his shading moves from top left to bottom right.*

103

Buildings and towns

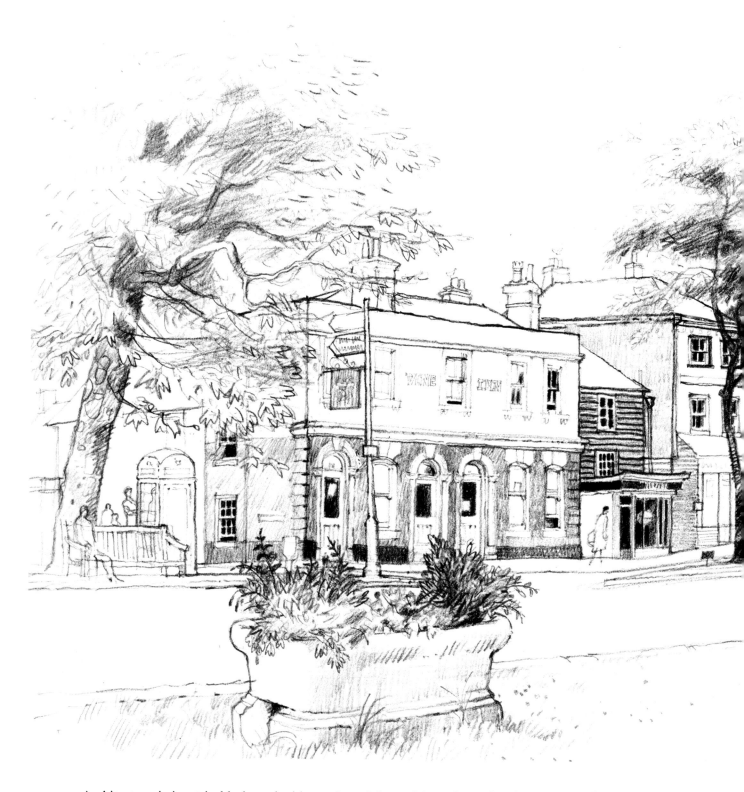

Architecture is inextricably bound with man's social and sometimes religious aspirations, and, as Clifford Bayly says, 'This is often reflected in the style in which our ancestors chose to build.' A bonus of drawing old buildings, therefore, is that in the process you will come into contact with the past.

If possible, then read up about the old buildings you wish to draw, for the more you know about them, the better you will understand their nature and character. Learn, also, the clues which will help you to identify their date and construction. Details of doors and windows, and the shape of roofs and chimneys, for instance, will all inform you to some extent of the period to which they belong. Remember, though, that styles

When drawing this town street, Clifford Bayly's main
concern was with the façades of the shops and the public
house, where the change from brick to wood cladding,
stucco to stone, and the variety of the windows from one
building to another provided him with a wealth of
interest. He deliberately left the roofs as blank shapes, for
although they presented interesting changes in surface
pattern, any further detail would have made the drawing
fussy. Notice how the church detail provides an
interesting foil to the amorphous mass of the tree on the
left, and how the stone trough in the foreground gives the
picture scale and depth, as do the people and cars.

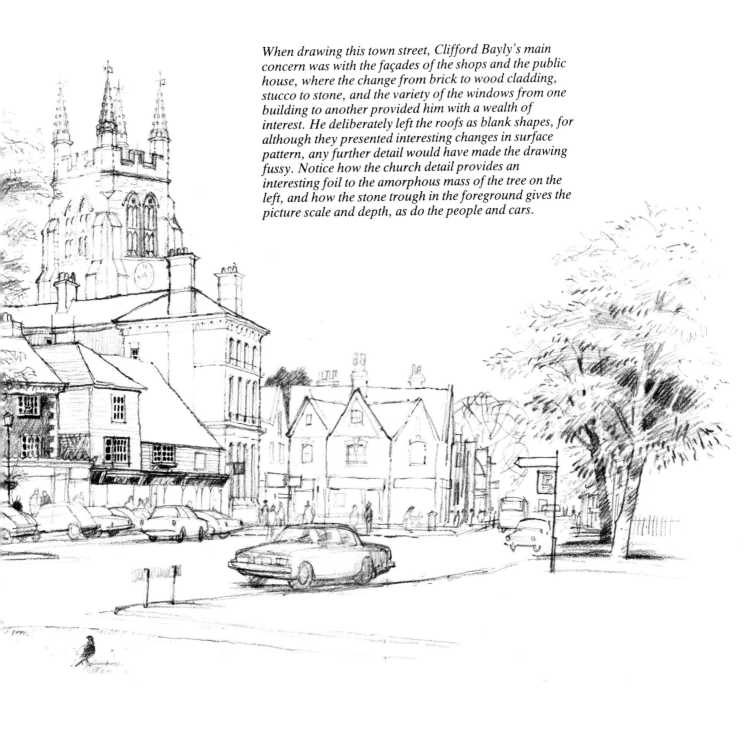

linger on in small places long after they have been
modified, changed, or superseded in the big cities.

The drawing above, by Clifford Bayly, illustrates the
variety of styles that might be found in a single street of a
small provincial town.

2B pencil drawing on rough watercolour paper, by Clifford Bayly. Mirror walls in modern architecture provide an interesting dimension to studies like this. Walk around such buildings to get the most dramatic reflection you can find.

Most artists do not find modern buildings as attractive to draw as older, less 'tidy' architecture. However, there is an increasing number of fascinating new buildings being completed almost every day in towns and cities, and there are many ways in which you can 'see' these buildings as new subject-matter to be explored; as possibly, an area in which new forms of expression can flourish.

The rather uncompromising nature of much modern architecture needs other elements in the drawing to relate them to human scale and to local conditions – weather, time of day, lighting, other more established buildings, even ancient ones – and, of course, people, gardens, plants, and traffic.

Strong perspective, even slightly exaggerated, can also add dramatic qualities but beware of over-exaggerated converging lines. They can become vulgar and destroy the character of your drawing.

One effective way to integrate modern buildings into the composition is to place them behind other, older

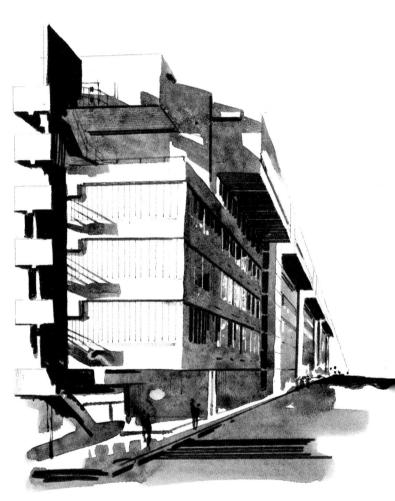

Melbourne office block by Clifford Bayly, drawn in 2B pencil and carbon crayon on cartridge paper. The traditional architecture in the foreground provides rich pictorial contrast to the impersonal lines of the modern building.

Pencil and ink wash drawing by Richard Bolton.

High-rise hotel block in Conté by Clifford Bayly. When you view buildings obliquely, two vanishing-points appear on your horizon line. This is demonstrated in modern buildings where they are composed often of box-like shapes or assemblages of large and small boxes.

buildings. The new ones form a backdrop to the more rich and complex architecture which has developed over a period of time.

In spite of the clean straight lines of much new architecture, refrain from using a ruler except in setting up the general masses and in checking perspective.

Large expanses of concrete or stone, even brick, can present problems. Where possible, try to vary the tone across these areas. Haze, smoke and clouds can also produce slight shadows to relieve the monotony. If they do not happen to be present when you are working 'on site', then you can produce what variation you feel to be necessary in order to balance the composition.

Interiors and still life

The way you place your possessions about your house is often an expression of your personality – so what better subject could you have, or one more familiar, than the interior of one of your own rooms? But, as you begin walking around your living-room or bedroom, you will notice how perspective controls or even dominates what you see, with apparently converging lines where ceilings join walls, where the lines of door-frames echo them, where the squared edges of tables 'angle off' to a vanishing-point. Demonstrations of how perspective works are given on pages 50–9. Here, although Clifford Bayly is using perspective, he is more concerned to show how, by moving about a room that is sparsely furnished and decorated, light from a single source (window or artificial) can determine your choice of viewpoint.

Firstly, he gives a room plan with a few pieces of furniture. The 'eyes' show the two viewpoints he selects.

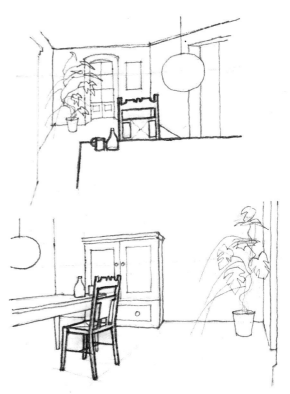

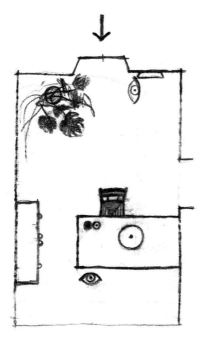

The two drawings on the top of this page show in outline what he sees: a view from a standing position behind the table looking towards the window, the other from a sitting position looking across the room. On the left of the page opposite he gives three tonal studies of these views: the top picture indicates the light source as coming from the window, the middle the same view by artificial light from the pendant lantern at night time.

The same viewpoint – but how different the two pictures are in composition! The relative tones of walls, objects and shadows are completely changed although the linear aspect is the same in both. Notice in the picture of artificial light how the window catches the reflection of the lantern and, because the lantern is at eye-level, how the picture glass reflects the light. The leaves of the house-plant appear as silhouettes in daylight – in artificial light their shiny surfaces reflect it.

In the bottom picture, the viewing point is close up against the side wall, the light from the window striking over the viewer's right shoulder from the window. Make such outline and tonal studies of interiors as you move slowly about your own room. Concentrate on the large masses and their shadows. Above all, start by having a single light source, if you have more than one, then close off all the sources except that which gives you the best potential for realizing your drawing. Only when you have blocked in the main shapes, add detail. Even though his room is almost bare, Bayly's drawings have plenty of interest, achieved by careful observation of how the room is lit.

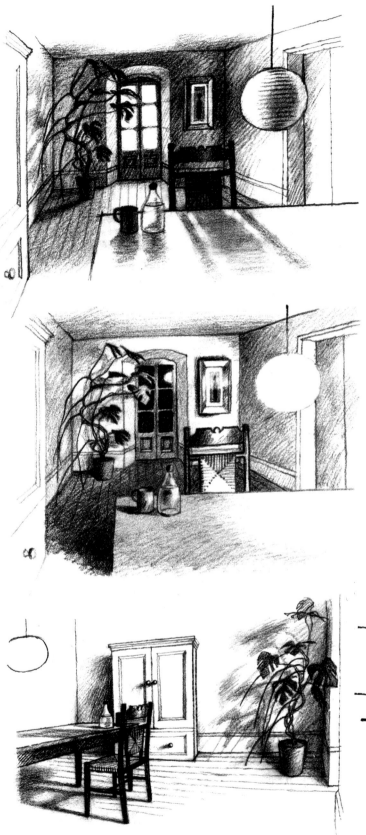

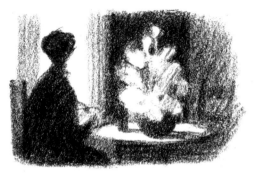

A quick tonal sketch in Conté showing dynamic use of silhouette and light falling on a vase of flowers.

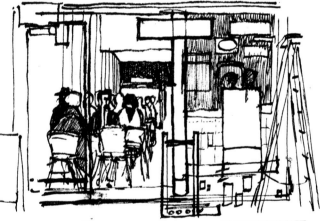

A quick fountain pen sketch of an interior seen from the exterior – a café interior seen through its plate-glass window.

Drawings by Clifford Bayly.

Interiors and still life

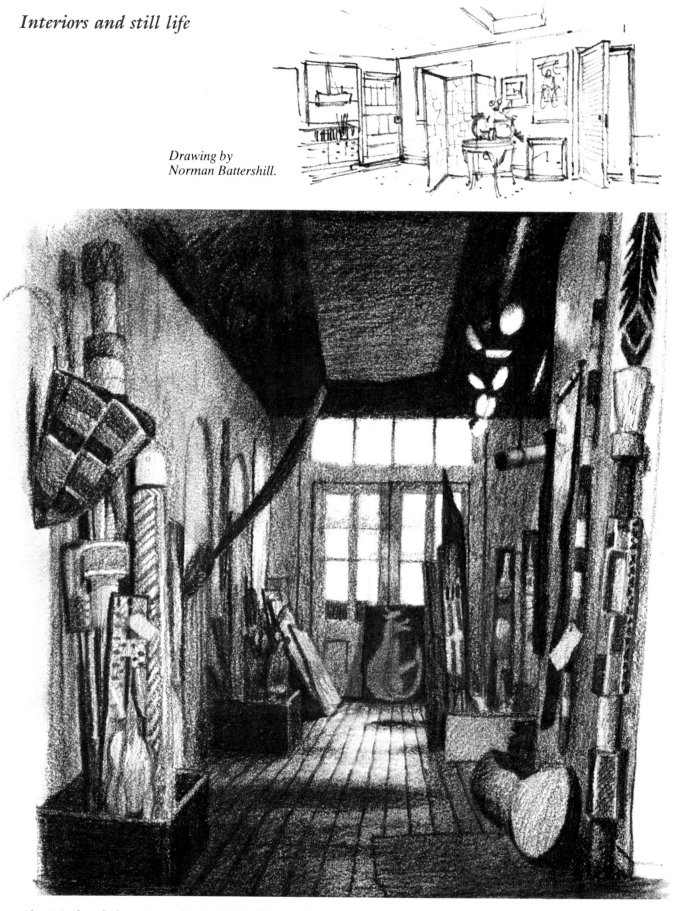

Drawing by
Norman Battershill.

Aboriginal craft shop, Australia, by Clifford Bayly, drawn in Conté on watercolour paper. Tone is an important element when representing light. The only white paper showing here is in the window and the overhead spotlights.

2B pencil and carbon crayon on smooth paper.
Here, Clifford Bayly has selected a smallish area
rather than a large panoramic view. He has also
placed comparatively small objects near to his
drawing position to add interest to the foreground.

This drawing by George Cayford, showing a
corner of his studio, is both an interior and a still
life. It was drawn loosely in fine felt-tipped pen,
with washes of diluted black ink of various
strengths applied with a brush.

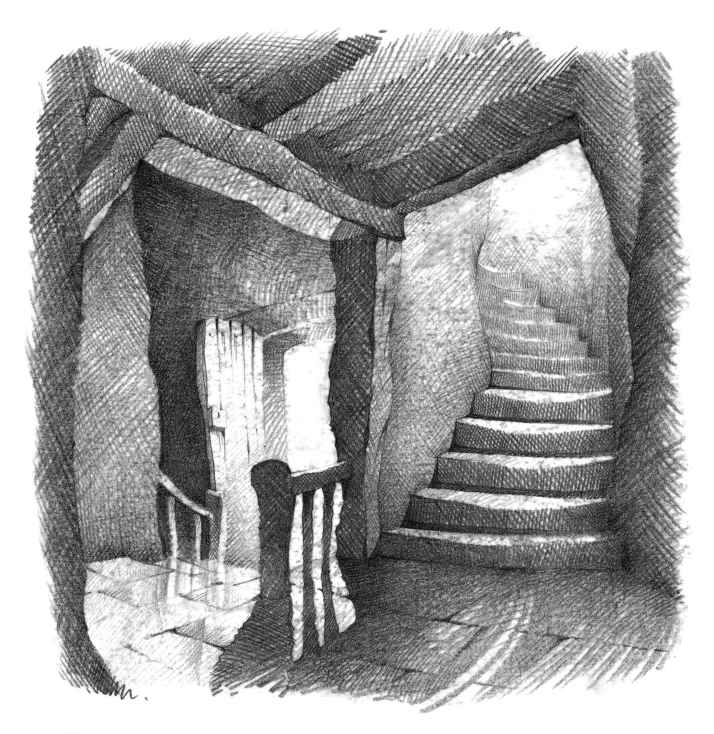

Pencil drawing by Peter Caldwell. This study has a vital air of mystery – there is an urgent need to know what is down the secret passageway. Look at the strokes and cross-hatching, and the texture of the rough stone steps and walls.

In this study, George Cayford drew the interior of the room and the view beyond in soft wax crayon. Then, using waterproof felt-tipped pens, he picked out the flowers in the window-box to show a contrast with the curtains. To obtain the soft flimsy effect of the net curtains, he rubbed out parts of the drawing with a typewriter eraser.

Interior of a café with figures, by Jack Yates, drawn with dip-pen and watercolour washes.

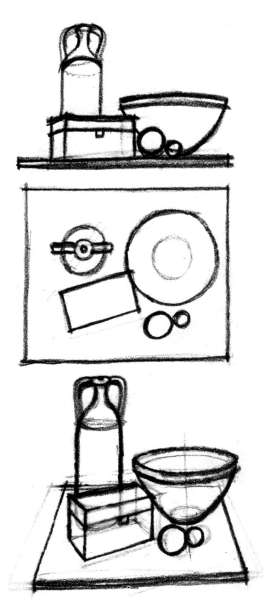

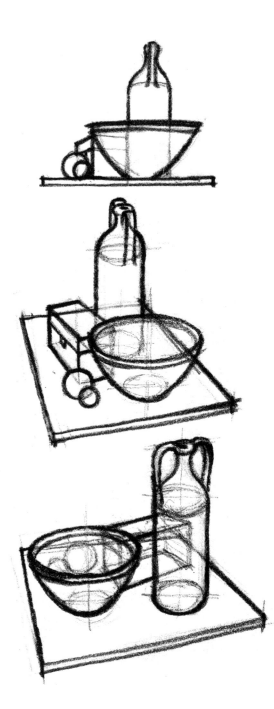

Drawings by Clifford Bayly.

Still life

Composing objects to make up a still life can be an aesthetic pleasure in itself, like flower arranging. Above, Clifford Bayly shows some of the salient elements that will help you to arrange still-life subjects, and to view them so that you will not only arrive at a composition which is pleasant to draw, but also interesting and possibly unusual. 'For your first attempts at still life,' he advises, 'use objects with simple basic forms and which are different in size and shape – tall, round, short, square, man-made as against natural or organic. Choose objects that, although different in form and texture, are related to each other in use or have associations, such as a season of the year.'

In the demonstration above, the plan (middle left) gives the arrangement of a few objects on a table. The line drawings above, below, and to the right of it all show those objects seen from different angles. 'Don't just sit down and start to draw,' Bayly adds. 'Take a careful look at the group from different positions – you'll find it will appear more balanced and pleasing from some viewpoints rather than others.

'Resist the temptation to move them about – you do the moving until you find which position will give you the best composition.' Bayly is telling you to practise by using the 'seeing eye'. Quick sketches or visual note-taking will tell you whether you want to settle down to draw from a position – it need only be a few lines and quickly blocked-in tones. Make several of these as you move around your still life, then contemplate them, eventually choosing the one you feel is the best.

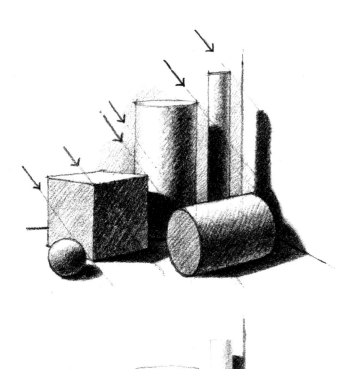

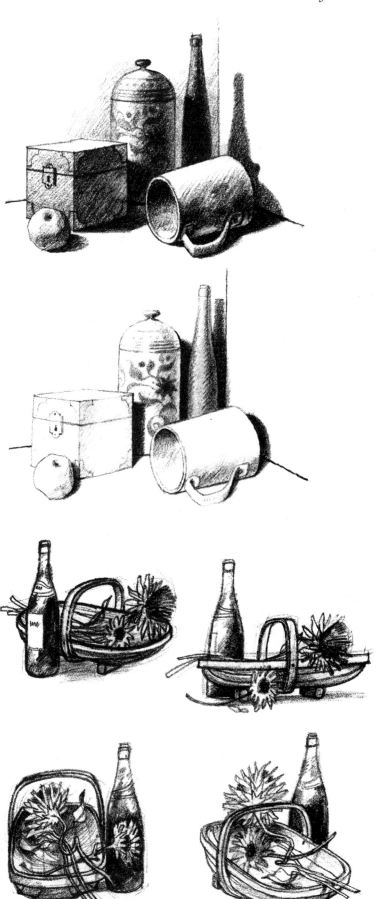

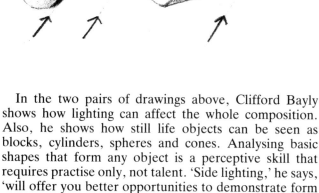

In the two pairs of drawings above, Clifford Bayly shows how lighting can affect the whole composition. Also, he shows how still life objects can be seen as blocks, cylinders, spheres and cones. Analysing basic shapes that form any object is a perceptive skill that requires practise only, not talent. 'Side lighting,' he says, 'will offer you better opportunities to demonstrate form and solidity, for the modelling is stronger and texture shows to advantage. The nearer the group is to the light source the stronger the contrasts are between light and shade.'

To the right, Bayly takes a few simple objects of differing textures, and from one viewpoint moves them about to achieve four different compositions. Notice how in each demonstration the different objects overlap and relate to each other – compositional lines and shapes cut across each other. The overall silhouettes too are lively and not static. Look for all these aspects when arranging your own still-life drawing.

Figures and portraits

Drawing the human form, whether in portrait or in the whole body, undoubtedly presents the supreme challenge to an artist and, to many, the greatest reward. But how do you start what might seem a daunting task? 'As with all drawing,' suggests George Cayford, 'try to depict what you see in front of you as best as you are able. It is the act of drawing that matters. Try drawing people on a large sketch pad, making many sketches of the same subject on the same sheet – it does not matter if they overlap. Put your drawings away for a couple of days and then, if possible, ask your model to assume the same pose and compare your drawings with the pose. This will put you in a properly critical frame of mind which will enable you to distinguish clearly the more successful parts from those less so.'

It is an excellent idea to join a local art class where life drawing is on the syllabus. 'Or ask a friend or relative to pose for you,' adds Jack Yates. 'People are less shy of revealing their bodies than when I was a student.' You could also try forming your own life-class with a group of friends, working in one of your own homes and sharing between you the cost of having a model.

Another way of drawing from a model or models is to ask permission to take your sketch pad along to a local keep-fit class or dance studio. It will give you good practice in looking at the human form, how it articulates, its variety and shape. The members may not hold poses for very long, but quick sketches of people in motion or momentary repose can be equally satisfying, and will build up your confidence in your drawing.

Swimming pools and beaches are another source. If there is a museum or gallery near you that has a collection of classical sculpture, again, get permission to draw these, for they are models that never move. Always try to draw from the three-dimensional figure, and not from photographs or illustrations, for in this way you train your eye and hand to interpret three-dimensional form.

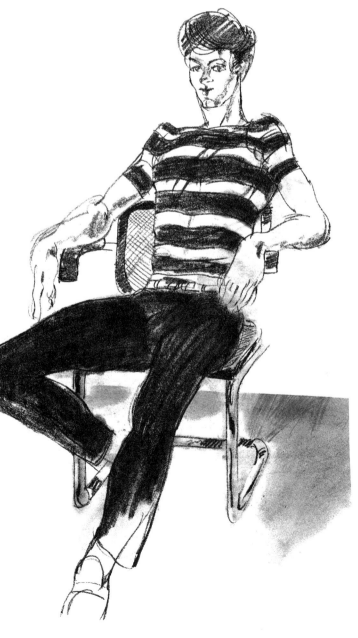

Drawings by George Cayford.

116

Body proportions

Before you start drawing, it is as well to understand the proportions of the human figure. The most easily learned, and the one most artists use, is to measure the body in heads. Generally speaking, the rule is that the height of an adult figure is eight times the depth of the head, or eight heads tall. From this rule the other dimensions and components of the body can be broken down into heads, arms, legs, and torso.

The rule applies to both the male and the female body, but obviously there are anatomical differences between the two. The male body is usually taller than the female. It is also wider at the shoulders and narrower across the hips than the female. In the diagrams below, George Cayford has divided a male and a female body into their respective 'heads'. You can see how the differences between the two sexes 'fit' into these divisions, or extend beyond them. If you get into the habit of assessing the models you draw by this rule of 'heads', and then adjust their individual proportions accordingly, you have a simple but effective means of drawing the human body in front of you, whether it is clothed or nude.

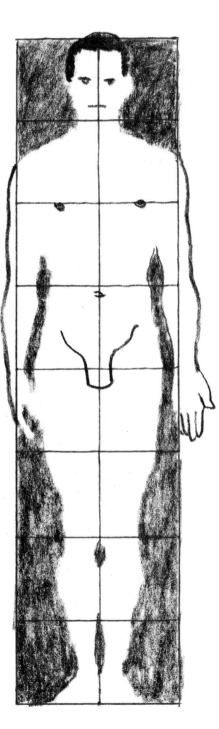

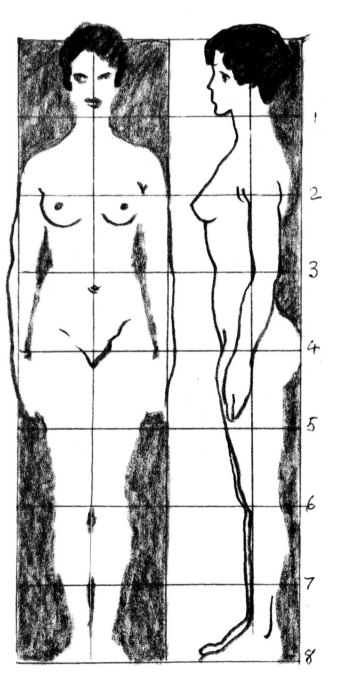

Figures and portraits

However, people do not stand in front of you like a diagram. They shift from leg to leg, they slump or stretch, twist and turn. The spine is the main support and strength of the body, and the body articulates from it. It naturally takes on an S-curve when viewed from the side but also assumes other curves as the limbs and torso move. Look for this main curve within the torso and then articulate head, shoulder and hip angles from it. Balance, too, is important to observe. The centre of gravity shifts as the body moves about and the 'centre line' moves accordingly, usually springing from near the foot where the body's weight rests.

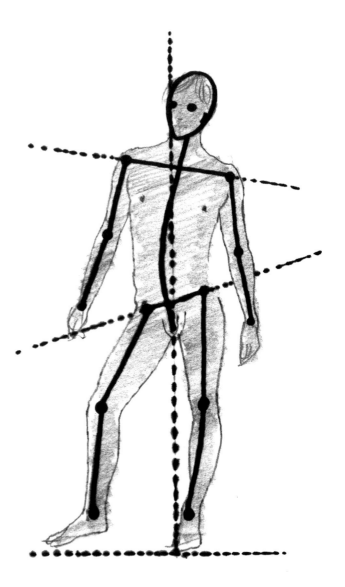

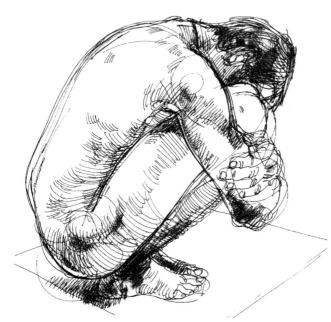

Notice how all the forms overlap in this crouching form – somewhat of a challenge, but think of the articulation lines and the pose will become less complicated to understand.

Lines of articulation in a standing male body with the weight on the left leg.

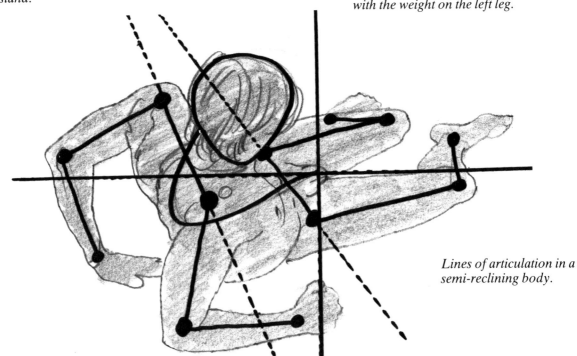

Lines of articulation in a semi-reclining body.

Foreshortening

As with all three-dimensional objects, the human body is subject to the rules of perspective. When you draw the body from close up, remember that those parts closest to you obey the rules of perspective and will appear bigger in proportion to those furthest away from you. The study below shows how George Cayford has drawn the knees and lower legs larger to emphasize how close to the model he was when drawing her.

'When I start to draw from the model', says Cayford, 'I usually make a few rough sketches to get the "feel" of the pose. As my pencil, pen or brush goes over the paper I am feeling outline, contour, mass. That is why in many of my drawings you can see where I have made several attempts to find the correct line. I always leave these construction lines in for two reasons: firstly, the model may move slightly before I have finished drawing and such lines help me to correct the pose; and secondly, I feel that they actually add to the description of my subject.'

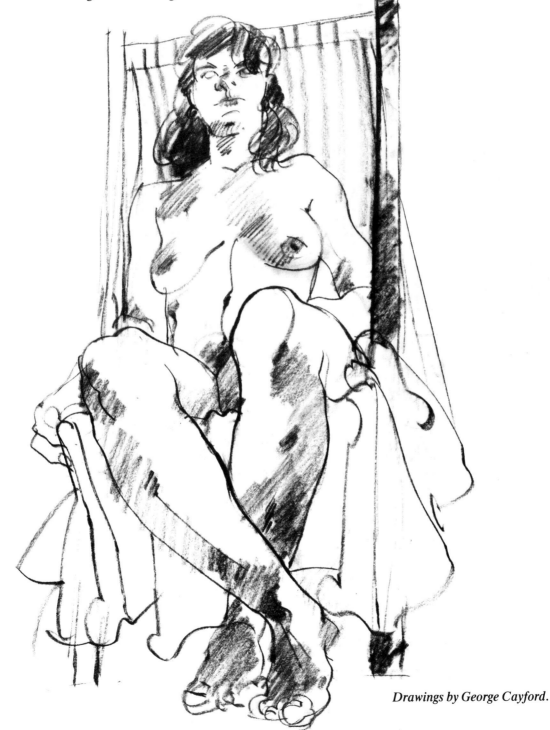

Drawings by George Cayford.

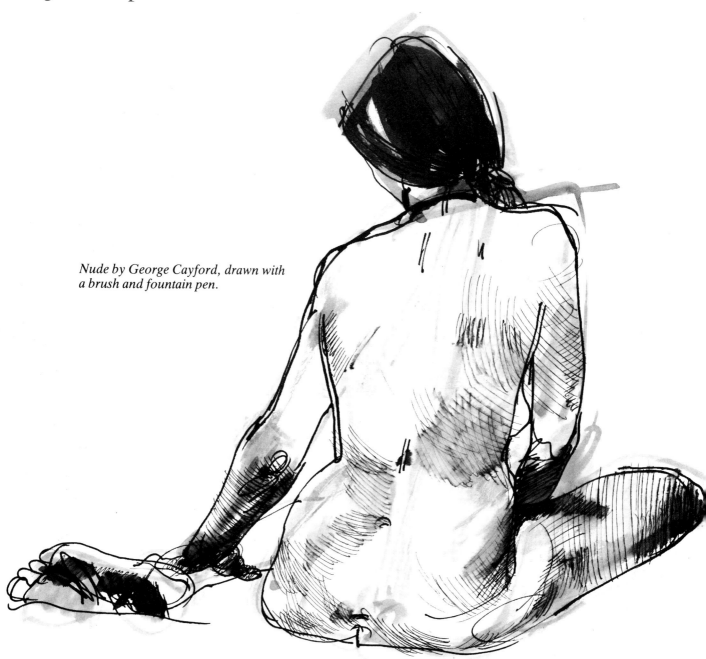

Nude by George Cayford, drawn with a brush and fountain pen.

Drawing the female form

Although the head proportions to the body are the same in both male and female – that is, eight head depths to each figure – the differences are quite considerable. The female body is smaller, the shoulders narrower and hips wider. The female carries more subcutaneous fat (breasts, hips, buttocks) and the limbs are more slender and rounded. Articulation is more pronounced around the hips because of the wider pelvic bones so that the female form appears more sinuous. When you draw the female form, think of the torso as being two tapering blocks, one from the shoulders to the waist, the other joining it at the waist from the hip-joints. These two blocks articulate at the waist and are held together by the spine.

When you draw from life, whatever your subject, try to rule out any preconceptions of what you think your drawing ought to look like. This will prevent you from glamorizing your female studies. Accuracy in putting down what you see in front of you is the criterion for any objective drawing.

Backgrounds can be as important or unimportant as you like to make them, but keep them simple: a cloth or drape is quite sufficient to set off the figure. A chair's shape can enhance a pose, but it should have some form of its own and not be a soft, upholstered object which detracts from the rounded forms and curves of your model. Avoid dramatic and 'photogenic' poses and gestures when posing your model – most drawings of these end up like caricatures.

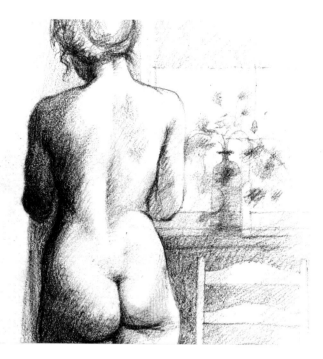

Nude by Clifford Bayly, drawn in 2B pencil on rough cartridge paper.

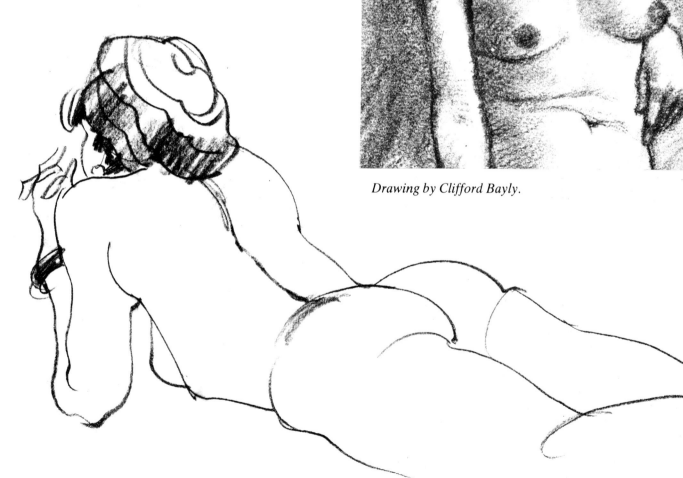

Drawing by Clifford Bayly.

Drawing by George Cayford.

Front view. Three-quarter view. Side view.

Drawing portraits

Drawing portraits is challenging and exacting. Not only do you have to satisfy your own artistic skills and judgement regarding your sitter, but also your sitter's opinion of what you have drawn. When drawing portraits you are tackling two things at once: an object – the head – which must also meet the criterion of being a likeness.

As a shape or form, the head can be thought of as an egg, with the point representing the chin. The height of the head, from chin to top, is one and a half times the distance between the cheeks. If you find difficulty in drawing the correct egg shape, then draw a circle (or sphere) and then add the chin to this circle. Always try to see the volume of the head: then you can add the features – eyes, nose, mouth and ears – more easily to it.

Above, are some simple guide-lines to help you construct the features on a head (or 'egg'). They will, of course, vary slightly from sitter to sitter. The top row of head shapes shows the head in full face, three-quarter face and profile. The parallel lines show the divisions along which the features generally lie.

Firstly, the head is divided into two equally sized parts. Along this line is placed the top of the ears and the eye-line. The lower half is then divided into two equal parts, and on the dividing line the bottom of the nose is placed. Divide this lower part similarly, and the bisecting line indicates where the mouth is placed. Notice that the depth of the nose corresponds to that of the ear.

Features

Eyes, noses, mouths, ears – these are some of the components of portraits. Their individual shapes and their relationship to each other on the head define identity and character – so practise drawing them separately and in combination. You will find that, with the probable exception of babies, no person's two eyes are replicas; the muscles a person uses in facial expression will, over the years, have pulled or developed each into a subtly different shape. So too with the mouth, one corner might droop or be upturned, or be affected by teeth (and dentistry). Think of features as simple geometric forms; parts of cylinders, or spheres. If you imagine them as being carved out of solid blocks, then your drawing instrument or medium can 'cut' through the block to the shape beneath. (See the drawings of ears on this page.) Notice too, how the angle of the head affects the shapes and relationships of features: such observation follows on naturally from looking at and taking note of foreshortening, as dealt with on page 119.

Sometimes, drawing the eyes presents problems to the beginner, for they are recessed into the skull in their sockets, yet they also protrude slightly beyond the surface of the face. This protrusion is best seen when the head is tilted upwards; the eyelids follow the contours of the eyeballs.

Drawings by George Cayford.

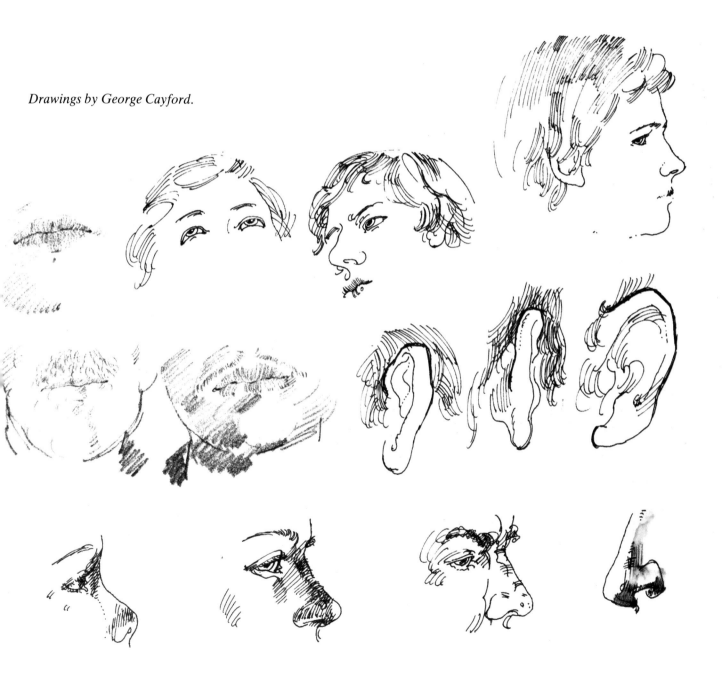

Figures and portraits

Noses come in all shapes and sizes but, generally speaking, they are wedge-shaped, with the nostrils forming two small hemispheres on either side of the base. The mouth is the most expressive part of the face, regarding its ability to change its shape, and it also has a different texture and a more complex formation. In fact, it is formed of two shapes, the upper and the lower lips. To understand its shapes, George Cayford has drawn a diagrammatic mouth in the diagrams below. In order to define the shape of the mouth more clearly, draw in the fine striations of the lips, which follow the contours.

Ears can protrude at an angle from the head or be flattened against it. Their twists and turns can be difficult to draw and it is best to think of the ear's main shape as a block or wedge. Draw it lightly as such, then 'carve out' its component shapes and curves as you draw it in.

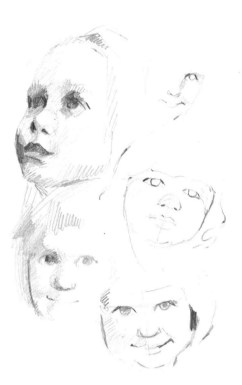

Pencil sketches of a child by Dennis Frost, made in preparation for a portrait in pastel.

Features and head by George Cayford. The head, although loosely sketched, bears out the underlying principles of drawing features: the wedge of the nose, the orbs of the eyes set in th skull, the striations on the lips defining their shape.

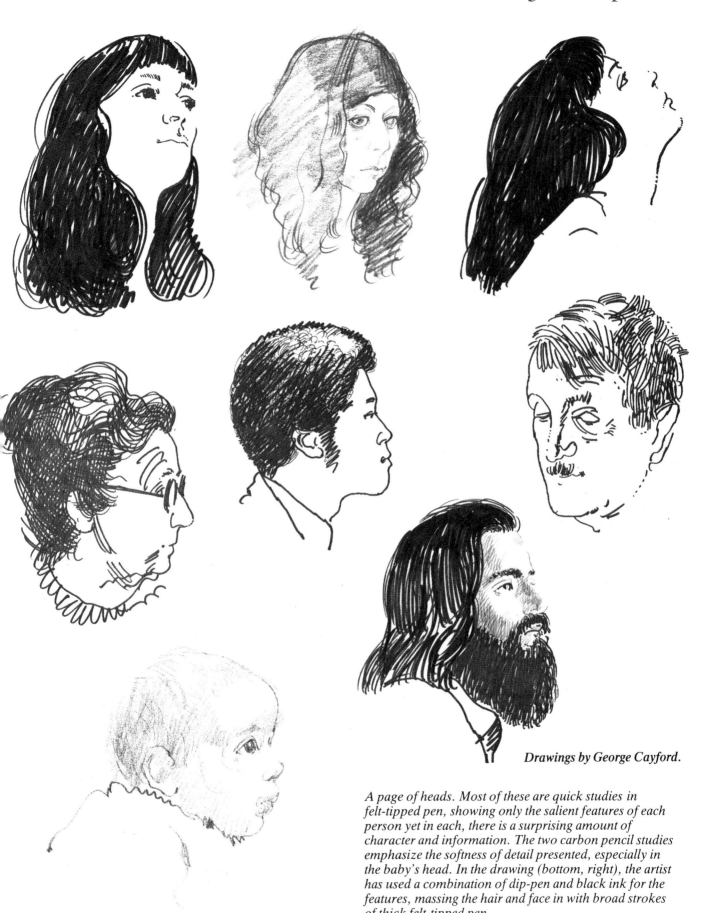

Drawings by George Cayford.

A page of heads. Most of these are quick studies in felt-tipped pen, showing only the salient features of each person yet in each, there is a surprising amount of character and information. The two carbon pencil studies emphasize the softness of detail presented, especially in the baby's head. In the drawing (bottom, right), the artist has used a combination of dip-pen and black ink for the features, massing the hair and face in with broad strokes of thick felt-tipped pen.

125

About the artists

Norman Battershill lives in Sussex, where he paints full time. He is a member of the Royal Society of British Artists, the Royal Institute of Oil Painters, the Pastel Society and President of the Society of Sussex Painters and the Arun Art Society. He is also tutor for the Pitman Correspondence Course in Pastel. He has written a number of books on painting and drawing.

Clifford Bayly was trained at St Martin's and Camberwell Schools of Art and has been a full-time writer, illustrator and landscape artist since leaving teaching. He is Senior Vice-President of the Royal Watercolour Society and he exhibits at the Royal Academy, the RWS Bankside and many other galleries. His work can be found in Europe, USA and Australia. He lives in the Weald of Kent.

John Blockley is a painter in watercolours and pastel. He has had many one-man exhibitions and his paintings are in collections all over the world. He runs private painting courses throughout the summer in various parts of Britain, and has served for a number of years on the councils of the Royal Institute of Painters in Watercolours and the Pastel Society.

Richard Bolton was once a technical illustrator but has painted full time for many years. He exhibits in many London galleries and in Boston, USA. Some of his paintings have been reproduced as prints. He lives in Cambridgeshire.

Peter Caldwell is a free-lance illustrator and a set designer for films and television. He trained at the Liverpool College of Art and now lives and works in Derbyshire. He organizes painting holidays in Britain and France, tutors in all media and has lectured in the Middle East on television design. His latest project has been working as a scenic artist for the Euro-Disney theme park, Paris.

Ray Campbell Smith FRSA is a professional painter who works in watercolours, oils and acrylics. He has had over thirty one-man shows and is represented in private and public collections throughout the world. He writes articles and reviews for magazines, gives frequent lectures, demonstrations and criticisms and has made six instructional videos. He has also written several books on painting.

George Cayford ARCA studied at the London College of Printing (where he is now a full-time lecturer) and the Royal College of Art. Starting as a graphic designer for major London ballet companies, he also taught at Maidstone College of Art. He has exhibited in London and Amsterdam and his work is in collections in England, Holland, Portugal and the USA. He lives in Hampstead.

Sylvia Frattini was born in Cumbria. She trained at Carlisle and at Hornsey Colleges of Art and now lives in Buckinghamshire. She is Head of Art at a high school in Luton. She has had several solo shows and regularly exhibits at the Royal Academy Summer Exhibition and the Royal Institute of Painters in Watercolours.

James Lester trained at Canterbury College of Art, and worked for many years as an art director and illustrator. He is a member of the Society of Botanical Artists and has exhibited in many national shows including the Royal Society of Painters in Watercolours and the Royal Society of British Artists. He now lives in Devon where he runs his own gallery and works full time as a painter and illustrator.

Margaret Merritt (also known as Margaret Pettersson) spent many years as official illustrator to several botanical expeditions in the Middle East. She is a teacher of both painting and botanical drawing, and her work is in collections in Britain, France, the USA and Iran. She lives in Surrey.

Sally Michel studied at the School of Art, Reading University. She is a member of the Society of Wildlife Artists and exhibits frequently, both in London and provincial galleries. She divides her time between drawing and painting wild and domestic animals, painting landscapes, creating line drawings of architectural subjects, and illustrating books.

Rosanne Sanders was born in Buckinghamshire and took a one-year basic course at High Wycombe College of Art. As she did not paint for many years after that, she regards herself as essentially self-taught. She has exhibited at the Mall Galleries, and the Royal Academy Summer Exhibition. She has won three gold medals for

her watercolours from the RHS and an RA Miniature Award.

Leslie Worth studied at the Royal College of Art, where he also taught for many years. Until recently he was Head of the Fine Art Department at Epsom School of Art and Design. He is a full member of the Royal Society of Painters in Watercolours and the Royal Society of British Artists.

Jack Yates studied at the Sheffield College of Arts and Crafts and is a teacher of figure drawing, portraiture, painting and experimental techniques. He has had many one-man shows in England and abroad and has exhibited at the Royal Academy. He also writes books.

Index